IMAGES
of America

AROUND HUNTER

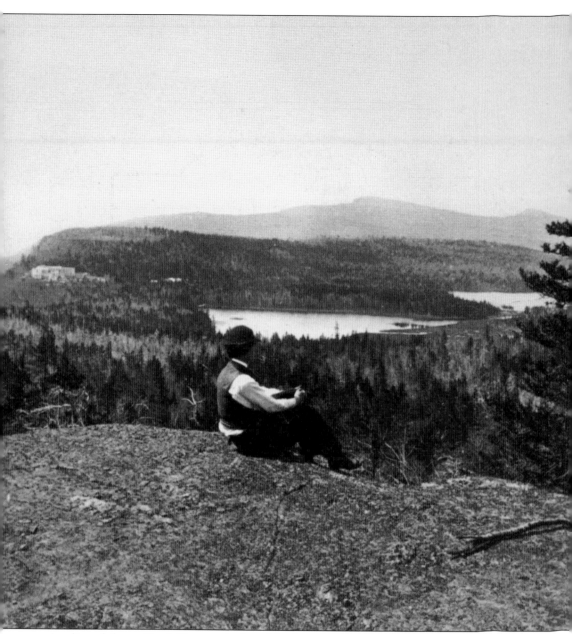

A solitary hiker at Bear's Den overlooking North and South Lakes around 1870 is enjoying one of the views that brought romantic artists and writers to the Catskill High Peaks around Hunter throughout the 19th century and into the 20th century. The famous Catskill Mountain House is visible in the distance. (Courtesy of the Mountain Top Historical Society Archives.)

ON THE COVER: Workmen take a break from building the Twilight Inn in Twilight Park, Haines Falls, New York. Twilight Park, founded in 1888, is one of several private parks that opened in Hunter in the late 1800s. The parks employed local builders to construct their cottages and also for special projects like the Twilight Inn. The inn burned down in 1926. (Courtesy of the Mountain Top Historical Society Archives.)

IMAGES
of America

AROUND HUNTER

Dede Terns-Thorpe and Cyndi LaPierre

Dede Terns-Thorpe *Cyndi LaPierre*

ARCADIA
PUBLISHING

Published by Arcadia Publishing
Charleston, South Carolina

Printed in the United States of America

Library of Congress Control Number: 2014955686

For all general information, please contact Arcadia Publishing:
Telephone 843-853-2070
Fax 843-853-0044
E-mail sales@arcadiapublishing.com
For customer service and orders:
Toll-Free 1-888-313-2665

Visit us on the Internet at www.arcadiapublishing.com

To the dedicated past Town of Hunter historians Justine Legg Hommel, Juanita "Bunny" Haines Showers, and Leah Showers Wiltse, we are building on your foundations.

CONTENTS

ACKNOWLEDGMENTS

Total immersion in the Mountain Top Historical Society's amazing archives has been a valuable learning experience for the two of us—the Hunter town historian and the president of the Mountain Top Historical Society. So many people have contributed to the archives during the past 40 years that the collection has grown to the point that there is enough to tell a good story about the town of Hunter. There have been far too many contributors to name individually. Sincere thanks go out to all of them. Our ability to tell the story is definitely a case of standing alongside those who have shared the information with us and our predecessors over the years.

Mountain Top Historical Society archivist and technology expert Robert Gildersleeve volunteered many hours of extra time in the archives to scan images and make excellent suggestions regarding the best images for this book. In addition, our thanks go to Gary Slutzky for generously opening his personal archive of postcards and photographs for the book and scanning the images we chose to use. Most of the images used in this book came from these two sources. All images without credits are from the Mountain Top Historical Society Archives. Those images from Gary Slutzky are credited to GS.

Our husbands deserve special recognition: thanks go to Ed Thorpe for his patience with the history books strewn across the living room and sunroom of the house for months, and a thank-you goes to Paul LaPierre for his patient guidance in the intricacies of computers.

This history does not include everyone or everything of note in over 200 years of Hunter history. We have sought to tell a good story, share some images, and be fairly accurate, but there is ambiguity. We do not have all the answers, just opportunities for further questions and additional research.

INTRODUCTION

On January 27, 2013, the town of Hunter began a year-long celebration of the bicentennial of its incorporation as a town. It was originally called Greenland, with the change to Hunter occurring on April 15, 1814. The town of Hunter is in the Catskill Mountains in Greene County, New York. The specific geographic region where the town is located is referred to as the Mountain Top. Its early development was a bit later than nearby areas that were closer to the Hudson River and had better soil and climate conditions for agriculture and easy access to trade along the river. There is still a divide in Greene County between the valley towns and the Mountain Top towns. To reach the town of Hunter from the Hudson River, which borders Greene County on the east, requires a drive of about 25 miles on state roads that climb steeply into the mountains. The three major routes into Hunter are Route 23A from the east and west, State Route 214 from the south, and State Route 296 from the north. All of these routes are two-lane roads with steep, winding portions through beautiful country that offer exceptional views of deep ravines, waterfalls, and forests.

The town of Hunter has an area of about 91 square miles and a full-time population of about 2,700. There are two incorporated villages in the town: the village of Hunter (incorporated in 1894) and the village of Tannersville (incorporated in 1895). In addition, there are five hamlets and three private residential communities. The hamlets are Edgewood (no longer a designated hamlet), Elka Park, Haines Falls, Lanesville, and Platte Clove. The residential communities are Elka Park, Onteora Park, and Twilight Park. The highest mountain in Greene County and second-highest of the Catskill High Peaks is Hunter Mountain (4,040 feet), located in the town of Hunter. The unique geological features of the region, the post-glacial ravines called "cloves" (from the Dutch word *kloof*, meaning the cleft in a hoof) are the scenic treasures of the town. The cloves are Kaaterskill Clove, Platte Clove, and Stony Clove.

In the 1708, as settlers colonized much of New England and the Hudson Valley, a land grant was made by Queen Anne of Great Britain to Johannes Hardenburgh and a group of associates from Albany and Kingston. The grant encompassed 1.5 million acres, including the land that would become the town of Hunter, and was intended to encourage development. But not much happened in the mountains as a result of that grant. They were considered wild and uninhabitable, difficult to reach and definitely not suited to agriculture. In 1749, Ebenezer Wooster was engaged to survey the property, and he divided it into sections called Great Lots, some of which included from 10,000 up to as much as 30,000 acres. The lots were split up among the original grantees and their heirs, but still the area was undeveloped. For years, Native Americans would pass through the area on hunting expeditions. John Bartram, a botanist from Philadelphia, Pennsylvania, made a couple of journeys into the mountains in the 1740s and again with his son William in 1750. They were looking for native plant species to share with botanists in England. Their detailed journals give an early photograph of the natural history of the still-wild forest.

It was not until after the American Revolution that a small settlement of Tory refugees and some people who fled from New England in the wake of Daniel Shays's Rebellion appeared in

a part of the future town of Hunter. These were people seeking the protection of the wilderness and willing to work hard to make a living. They farmed the rocky soil despite the short growing season. They trapped mink to sell to fur traders, hunted the abundant wild deer, rabbits, and turkeys, built a sawmill near the confluence of the Roaring Kill and the Schoharie Creek at Dibbell's Dam, and lived quiet lives.

Additional people moved into the area around the turn of the 19th century to take advantage of the twin resources of the vast stands of hemlock trees and the many streams available to make tanning leather a viable entrepreneurial option. The population grew from less than 400 in 1810 to 1,025 in 1820 and up to 2,433 in 1840. The tanneries provided jobs directly and indirectly. Bark-peelers cut down and stripped the hemlocks. Teamsters brought hides up the steep mountain roads on ox-drawn wagons and sledges. There were multiple men employed in the tanning process itself. Farmers provided room and board for the itinerant bark-peelers. The largest tannery in Hunter (and one of the largest tanneries in New York State) was owned by Col. William Edwards. It was built along the Schoharie Creek on what is now Main Street in the village of Hunter in 1815. At its peak, the tanning industry in the town of Hunter shipped 5,000 hides a year down the mountain to the Hudson River and on to the leather market in New York City. By the mid-1800s, the supply of hemlocks was being exhausted. The tanneries were slowing down. Demand for leather during the Civil War kept some tanneries in business, but the last tannery closed in 1885.

The decline of the tanning industry was followed by the growth of businesses dealing in other wood products. White pine and hardwood lumber was harvested and shipped to Philadelphia and New York City for the furniture and shipbuilding industries. As the tanneries disappeared, various wood products factories grew up, lining the main street of Hunter: chair factories, turning factories, bedstead factories, an excelsior producer, and cooperages. The dense forests that had covered the town were all contributing to the industries that kept Hunter viable. All of these enterprises were enhanced by the coming of the railroad to Hunter in 1882. Sending the wood products to New York City and beyond was now much easier than in the days of the ox- and horse-drawn wagons that had served the tanneries. In addition, the railroad brought more employment options—building, operating, and maintaining the tracks and trains.

The mid-1800s were also the peak years for agriculture in the town of Hunter. The small, rocky, hilly farms were marginal at best. Much of the acreage devoted to agriculture was used as pasture for some dairy cows, small herds of beef cattle, sheep, horses, and oxen. Due to the difficulties related to farming in the Catskills, most farmers worked at more than one job to supplement their incomes. There was always demand for labor in the tanneries, in the lumber and wood-products industries, in ice harvesting, in maple-sugar production, in building, in service in the boardinghouses and hotels, or providing fresh milk and vegetables to the boardinghouses and hotels, in the bluestone quarries, and in the seasonal pursuits of hoop-pole shaving and shingle-weaving. In the late 1800s, there was a migration from the mountain farms to the valleys and urban areas. The population in the town of Hunter had dropped to 1,564.

While entrepreneurs in the tanning and wood-products industries were cutting down the forests, another group of businessmen was building livelihoods on the natural beauty of the area. In addition to the botanists John and William Bartram, who explored the forests in the mid-1700s, visitors to the Mountain Top included the writer James Fenimore Cooper in 1820 and artist Thomas Cole around 1824. Cooper visited the site called Pine Orchard and ecstatically describes both the vista as seen from that spot and the nearby Kaaterskill Falls in his book *The Pioneers*. Cole immersed himself in the wild, hiking through Kaaterskill Clove past Kaaterskill Falls to the area around North and South Lakes. From his home in Catskill, he set off into the Catskills, introducing other artists and writers to its beauty. His explorations extended throughout the area around Hunter from the Pine Orchard to Platte Clove. His paintings of "America's First Wilderness" struck a chord in the minds and hearts of romantic writers, poets, artists, and travelers. Washington Irving wrote "Rip Van Winkle" without even visiting the Catskills and stirred a similar interest in the magical places in the mountains. The Catskill Mountain House was built in 1824 by Charles Beach and associates at the Pine Orchard site, taking full advantage of the most

spectacular vista of the Hudson River Valley. By the post–Civil War period, vacationing in the Catskills had become very fashionable for wealthy urban dwellers. Other large luxury hotels were built in the vicinity of the Catskill Mountain House. Many of the marginal farms were converted to boardinghouses as the resort industry grew. Additional smaller hotels and boardinghouses were constructed to provide rooms for people from New York City seeking clean air, pure water, fresh food, and relief from the summer heat. The same railroad that served the wood products industry and local agriculture was a boon to the tourist industry in the town of Hunter. In 1900, the population of Hunter reached a new high of 2,788.

The early years of the 20th century were busy ones in the town of Hunter, led by the tourist boom. In 1904, the New York State Legislature designated the boundaries of the Catskill Park, marking a new era of preserving forests and acquiring land for New York State Parks. The town of Hunter is wholly within the Catskill Park. Private residential parks in Hunter were developed beginning in 1883, as cottages were built as summer homes for upper-middle-class families seeking to escape post–Civil War urbanization in a private setting. Cottages in Onteora Park, Twilight Park, Sunset Park, Santa Cruz Park, Philadelphia Hill Park, and Elka Park were simple and primitive. They were built without kitchens, and cottagers dined in their park's clubhouse after spending a day outdoors amid the wild beauty of the Catskills. These parks employed local people as carpenters, plumbers, gardeners, cooks, laundresses, housekeepers, and winter caretakers.

However, the 20th century brought major changes in the vacation habits of Americans, which affected the large hotels that housed so many tourists in the Catskills. As automobiles became the norm rather than the exception, people no longer traveled only to the places reachable by train. They also no longer spent weeks in one place. Additionally, the stock market crash of 1929 and the beginning of the Great Depression took the wind out of the sails of the tourist boom in Hunter. The local economic decline continued through World War II, as war-related industries in urban areas drained human resources in rural areas. During the 1960s, unemployment rates in Greene County were 20 to 50 percent higher than national levels—except during seasonal employment peaks.

On January 10, 1960, two local businessmen, Israel and Orville Slutzky, opened Hunter Mountain Ski Bowl and ushered in the beginning of a year-round tourist economy. Skiers from New York City and environs flocked to Hunter during ski season, giving another chance to the many smaller hotels and boardinghouses. It was a beginning. The population figure for 1970 was 1,742, about 1,000 fewer permanent residents than in 1900. The 1970s brought large numbers of urbanites to the Hunter area in search of second homes. The meeting between the budding economy of the Catskills region and the land-seeking New Yorkers triggered massive land speculation and uncontrolled land development. The delicate balance between economic growth and small-town rural life is still being worked out.

The most positive developments in the 21st century are coming from the current trends in travel and vacations toward outdoor activities and cultural/historical tourism. The town of Hunter still has the rich natural beauty that drew the romantic artists and writers in the 19th century. The state parks offer miles of well-maintained hiking trails with breathtaking vistas. North-South Lake State Park and Devil's Tombstone State Park also have camping facilities. Within the town of Hunter and in nearby towns, there are waterfalls, bicycling, mountain biking, fishing in lakes and streams, canoeing and kayaking, bird-watching, swimming, golfing, and rock and ice climbing. The restored Hunter Mountain Fire Tower sits atop Hunter Mountain at 4,040 feet, a great hike that rewards the hikers with spectacular views. Hunter Mountain offers skiing, snowboarding, and snow-tubing on 240 acres of well-groomed trails. In the off-season, Hunter Mountain offers its Skyride to the summit for sightseers. The autumn foliage is well worth the trip to see. Hunter Mountain is also a venue for concerts and festivals in the summer.

The Mountain Top Historical Society maintains a visitors' center in Haines Falls with interpretive panels for the Hudson River School Art Trail. It also offers a three-season schedule of lectures, guided hikes, and other events. The Catskill Mountain Foundation in the village of Hunter and in the Orpheum Theater in Tannersville presents music and dance events that include classical,

jazz, rock, and classical and modern dance. The movie theaters in the villages of Hunter and Tannersville are also run by the Catskill Mountain Foundation. Each year, community theater groups Greene Room Players and Schoharie Creek Players present programs. There are antique dealers, art galleries, and small shops in both villages along with a variety of places to dine.

One

THE EARLIEST SETTLERS

According to an article written by Esther H. Dunn and published in the *Twilight Owl* in 1972, the earliest settlers came to Hunter in the late 1700s. The records compiled by Dunn's mother, Jennie Haines Dunn, were the basis for the information in the article. The source for Jennie Dunn's research was a treasure trove of records related to the Hardenburgh Patent that were found in a locked safe that had belonged to John Hunter, a son-in-law and heir to James DesBrosses, a grant holder under the Great Patent. Those records are now held by the New York State Historical Association in Cooperstown, New York. According to the information in the Hardenburgh Lease books found in the safe, the majority of the pioneers to the Mountain Top area were from Connecticut, lower Dutchess County, and Westchester County.

One group of families came up through Mink Hollow and settled in the Platte Clove area. William Miller, Gershom Griffin, and Daniel Bloomer were among the Platte Clove settlers. Samuel Haines, who came to the area with his brother Elisha in 1780, is said to have the first recorded permanent lease in Great Lot No. 25, granted in the year 1791. His lease was for Lot No. 4, containing 175 acres of land.

These earliest settlers moved stones and cut down trees to clear fields. The stones were used to build walls that can still be discovered as one hikes through the Mountain Top woods. The trees were used for building crude shelters for their families. They kept animals, planted gardens, and hunted for meat and for skins to sell. Sawmills were built to provide the lumber needed to improve their living conditions. Simple tanning operations were set up on farms. These earliest settlers were hardy pioneers.

Alf Evers writes in *The Catskills: From Wilderness to Woodstock*, "I once asked a man who lived within the shadow of Plattekill Mountain just where the Catskills began. 'You keep on going,' he said, 'until you get to where there are two stones to every dirt. Then b'Jesus, you're there.'"

Near this bridge was the site of one of the first sawmills in the Kaaterskill region in the late 1790s. It was first owned by Alexander Moore of Mooresville near Grand Gorge and then by John H. Moore until it burned down.

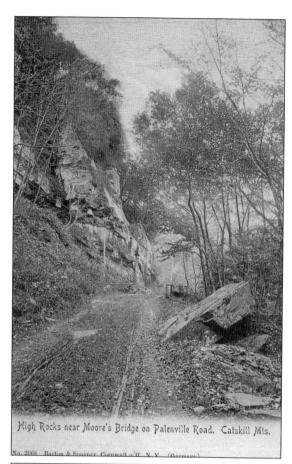

High Rocks near Moore's Bridge on Palenville Road. Catskill Mts.

No. 2008 Barton & Spooner, Cornwall o'H N. Y. (Germany)

East Hunter was an early settlement down in Kaaterskill Clove on the flats below the falls and cascades. This view shows the old road across the flats before it ascends the mountain. The settlement was once known as Williamson, and the post office designation was East Hunter. There is a historic marker along New York State Route 23A showing the location of the Kiersted tannery. (Photograph by Loeffler.)

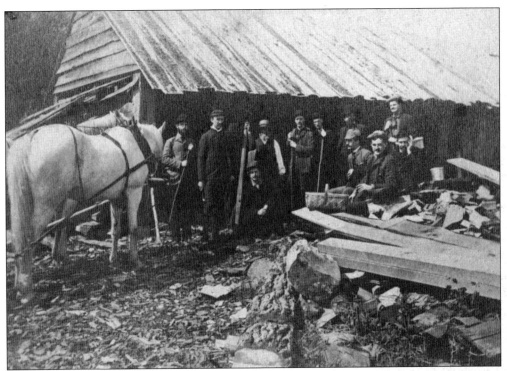

The old sawmill at Haines Falls belonging to Charles W. Haines (father of Jennie Haines Dunn) was located near upper Sunset Bridge on the property that was later used for the Mountain Golf Club. The mill was originally built by Aaron Haines in 1848–1849. The man in the center of the group wearing the straw hat is Charles W. Haines. Below is another photograph of the Haines sawmill, including the millpond. In attempting to rebuild the dam around 1900, workmen left sparks that resulted in burning the mill to the ground.

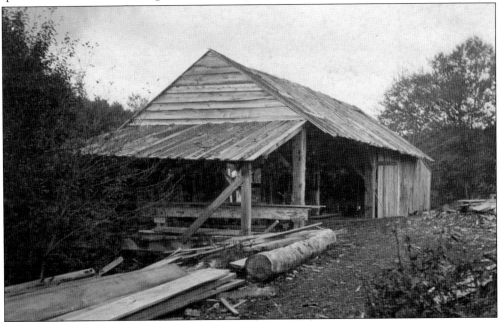

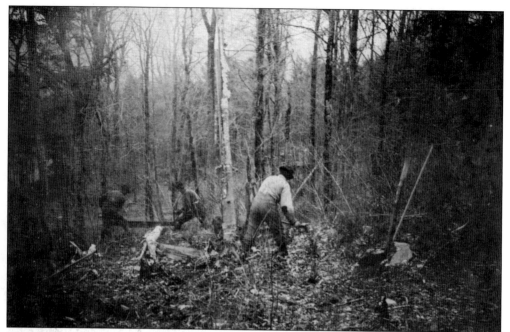

These men are working in the woods clearing trees for building. The men are identified as Henry France working with Ed and Will France. They are clearing property in the newly formed Twilight Park in Haines Falls. This is the type of heavy work facing all of the early settlers to the area around Hunter. The photograph was taken by a Mr. Packard in 1888.

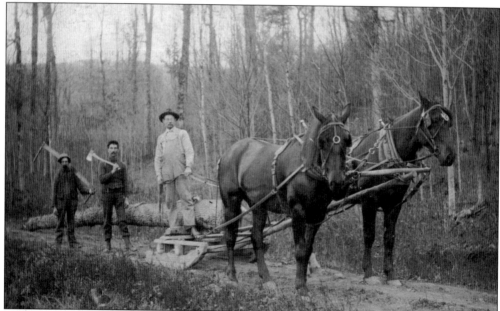

A team of horses is pulling a sledge to haul a log from the woods to the sawmill in the 1880s. A sledge was used more frequently than a wagon for this kind of transport. It was better suited to the rutted, stump-riddled trails. The horses, Prince Henry and Teddy Roosevelt, belong to Elmer Pelham, who bought them for $600. The driver is Arthur Moore; his helpers are Ed France and Harm Schoonmaker.

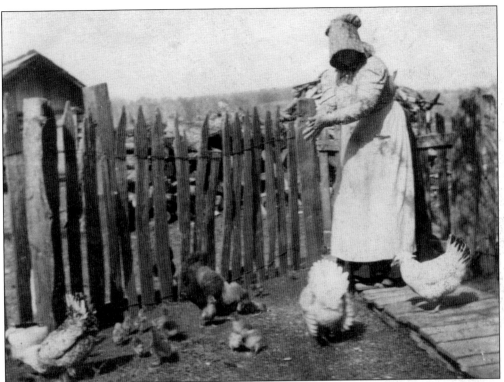

In the late 1700s and early 1800s, most homesteaders raised poultry, mainly chickens, for eggs and meat for their own consumption. Women and children cared for the chickens, which hung around the house and barn. They were mostly fed what they could scrounge around the barnyard and garden, possibly supplemented by some corn.

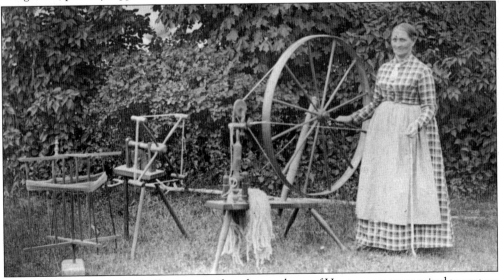

The short growing season, shallow stony soil, and steep slopes of Hunter were more suited to pasture than to crops. Farmers raised sheep for wool to be spun into yarn and made into clothing by their wives. In addition, there were a few commercial woolen mills in the area around Hunter. In this photograph, Lucy Haines Rusk Martin is at her spinning wheel on the farmhouse lawn.

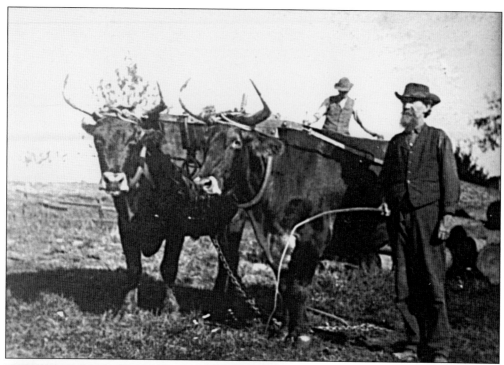

An oxteam, probably owned by James Rose, is hauling logs in Elka Park. Oxen were used in the Catskills for plowing, transporting heavy loads, and skidding logs from the forest. They are able to pull heavier loads for longer periods of time than horses. Given the nature of farming, logging, and hauling in the mountains, oxen were well suited to the work.

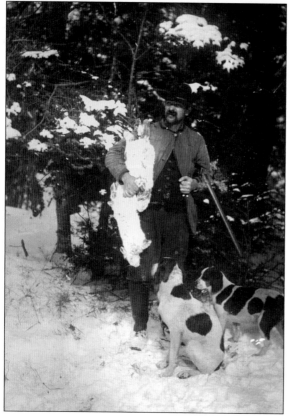

The farm diet was always supplemented with wildlife caught in the abundant forests on the Mountain Top. This is Chris Martin coming out of the woods with a good catch of rabbits, accompanied by his hunting dogs. Deer and turkeys are also plentiful.

Two

BUILDING ROADS AND GROWING VILLAGES

In the 1700s, the Hudson River was the highway north to Albany. The unique Hudson River sloops and then later commercial steamboats transported goods and people from New York City into upstate New York. The Catskill Mountains around Hunter were beautiful and majestic as seen from a distance in the Hudson River Valley. As a place to visit, they were wild, steep, and rocky. Early roads for transporting goods from Catskill followed a northern route through the mountains around Durham, west through Windham, and on to Prattsville. From there, Hunter could be accessed from the west through the Schoharie Valley. There were trails through the steeper parts of the forests crowning the eastern escarpment that were used by botanists, explorers, hunters, and Native Americans passing through. One of the earliest roads into the Hunter area was cut through Mink Hollow from Woodstock in Ulster County, entering Hunter from the south in Platte Clove.

In 1823, a group of Catskill businessmen formed the Catskill Mountain Association with a plan to build a hotel on the spot on the eastern escarpment overlooking the Hudson River Valley called the Pine Orchard. The association built a road using an older path that was already in place and provided direct access to the Pine Orchard. This was called the Sleepy Hollow route. The Hunter Turnpike (as a company) was in operation in 1814 but did not build its road (an improvement on a 1793 road) through Kaaterskill Clove to Prattsville until 1824, when the tanneries made it profitable for the company.

In the early 1900s, the automobile made additional improvements to the Clove Road a necessity. In 1913, convicts from Sing Sing prison started construction on a new four-mile road (eight percent grade) from Palenville to Haines Falls. It took 50 convicts about two years to complete the work. Some of the grades were 175 feet above the creek bed in the gorge. This improved road was dubbed the Rip Van Winkle Trail.

As improved roads brought more and more people into the area, the villages along the route grew.

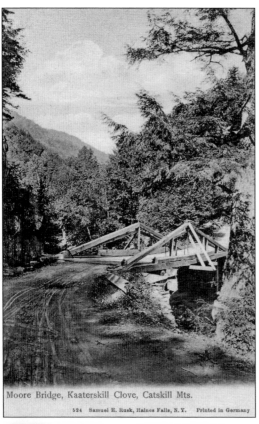

Moore Bridge, Kaaterskill Clove, Catskill Mts.

524 Samuel E. Rusk, Haines Falls, N.Y. Printed in Germany

Moore's Bridge crosses Kaaterskill Creek near the east end of the Kaaterskill Clove Road, as seen in this photograph by Samuel E. Rusk from Haines Falls, New York. The bridge may have been named for the nearby sawmill. Or it may have been named for Sheriff Moore, who was Greene County sheriff in the mid-1800s, or artist Charles Herbert Moore, who resided just north of the present Rip Van Winkle Bridge. (Courtesy of GS.)

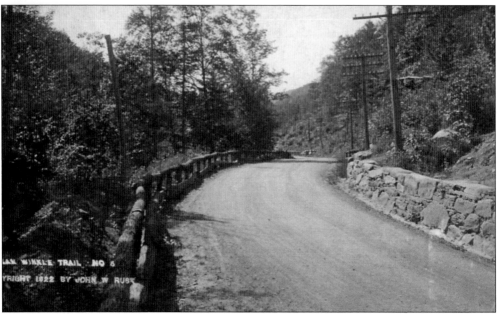

The Rip Van Winkle Trail was the name given to the improved road through Kaaterskill Clove. Taken by John W. Rusk, this 1922 photograph has a view looking west above Moore's Bridge near Fawn's Leap. (Courtesy of GS.)

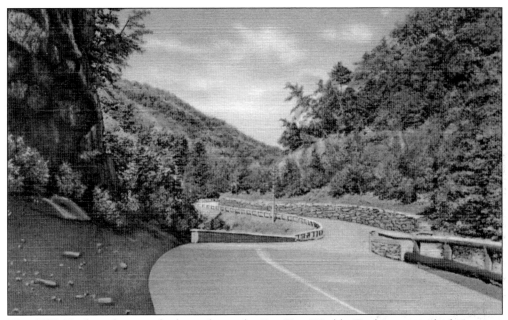

The C.W. Hughes photograph above shows the Rip Van Winkle Trail in a view looking west. The photograph below documents a washout on the Rip Van Winkle Trail about half a mile west of the bottom of the clove that occurred a few years after improvements were made around 1930. This is an illustration of the difficulties inherent in a road built in a steep gorge such as Kaaterskill Clove. Heavy traffic and stormy weather continue to produce road-closing events on what is now referred to as New York State Route 23A. The most recent washout was a result of Hurricane Irene in August 2011. (Both, courtesy of GS.)

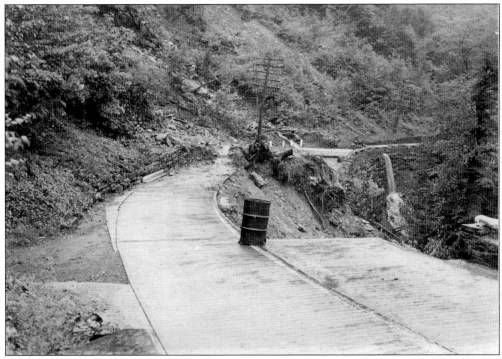

The Rip Van Winkle Trail makes a horseshoe bend near Bastion Falls. The falls are impressive, but a half-mile hike on the trail next to Bastion Falls yields an even more spectacular view of the famous Kaaterskill Falls. This is a Bob Wyer photograph taken in 1949. (Courtesy of GS.)

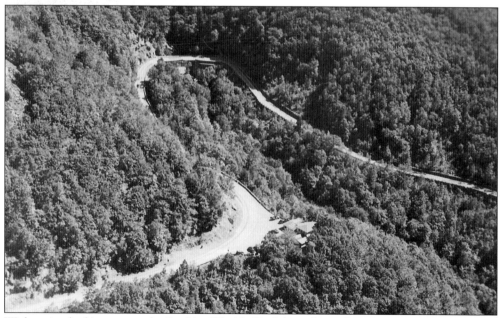

With a view looking east at the Rip Van Winkle Trail from the parking lot at Rip's Lookout, this Bob Wyer photograph from 1949 gives an idea of the nature of the road. The horseshoe bend is clearly visible. This road is viewed either as a thrill ride or as a frightening experience. For people who live in the Mountain Top, it is just part of everyday life. (Courtesy of GS.)

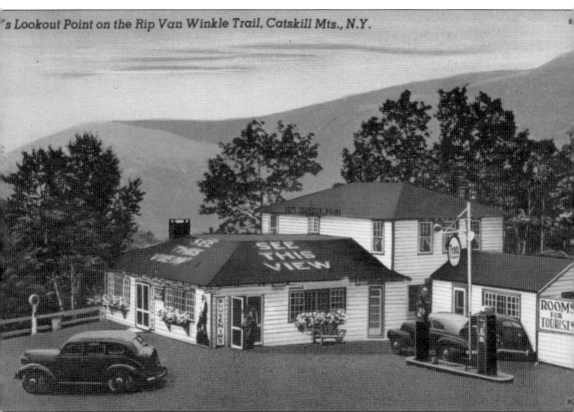

After passing the falls while going west, travelers were offered a spot to stop for a break. It was a souvenir stand called Rip's Lookout. There was a viewing glass for tourists to see the rock where Rip slept on the side of the mountain for 20 years. The parking lot could hold about 10 cars. The business sold Tydol gasoline and had water for the cars that overheated on the trip up the mountain. Some people recollect that they also had the smallest ice-cream cones money could buy. A friend tells about the day she was working in the kitchen at Rip's when a car crashed through the gift shop, smashing all the glass trinkets and figurines. She had the presence of mind to grab a paper bag and collect the money from the cash registers so it would not be lost in the chaos. Rip's owner was so impressed that she raised the resourceful girl's pay from $17.50 a week to $21 a week. The owner was Mollie Voss Smith, the great-great-grandmother of the present Town of Hunter supervisor, Daryl Legg.

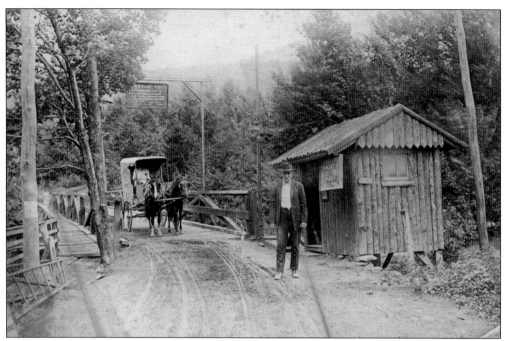

Farther up the Rip Van Winkle Trail, on the south side, is the entrance to Twilight Park, Santa Cruz Park, and Sunset Park. These private parks were started in 1888. The entrance crosses the Kaaterskill Creek above Haines Falls. The sign hanging over the bridge reads, "Notice to all Automobilists, Speed Limit 5 Miles per Hour, Stop on Signal. Drivers of Carriages and Pedestrians Have Right of Way."

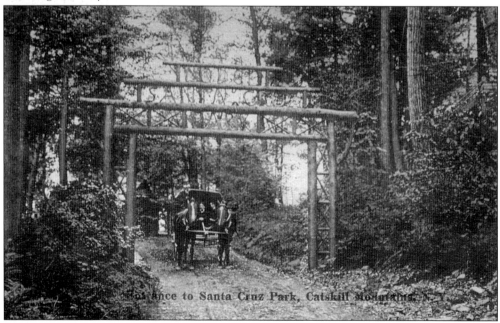

The entrance to Santa Cruz is inside the park area, beyond the bridge in the previous photograph. The rustic style of the entrance marker is typical of the private parks in the Hunter area. (Courtesy of GS.)

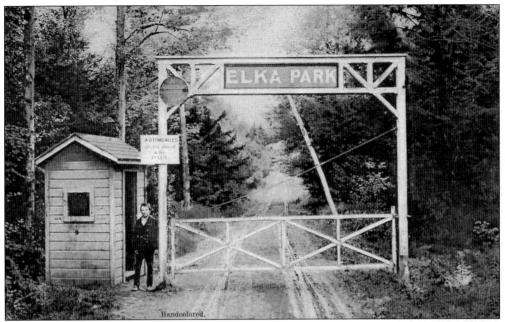

Elka Park was started in 1889 in the Platte Clove area of the town of Hunter. It is smaller than Twilight Park or Onteora Park; however, it has a similar ethos, valuing family and country life. Time spent in the parks is time away from hectic city life. In Platte Clove, there is a hamlet of Elka Park with a post office and a private park named Elka Park. (Courtesy of GS.)

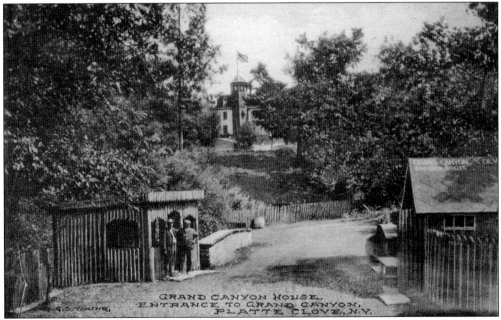

Platte Clove, referred to as "Grand Canyon," is one of the three major cloves in the Catskill Mountains leading from the valley to Hunter. The road is precipitous and even today only kept open during spring, summer, and fall. In season, it is a popular shortcut to the Saugerties-Woodstock area. The Grand Canyon House was located on the property near the top of the road. (Courtesy of GS.)

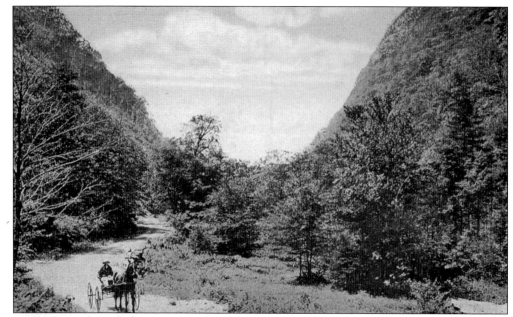

The third clove road to Hunter after Kaaterskill Clove and Platte Clove was from the south through Stony Clove from Phoenicia. The hamlets of Lanesville and Edgewood are both located in Stony Clove. The road through the notch (now New York State Route 214) passes the Devil's Tombstone State Park, just south of the village of Hunter. (Courtesy of GS.)

The Ulster & Delaware Railroad built a line through Stony Clove beginning in 1880, bringing the first train into Hunter in 1882. The coming of the railroad marked the height of the resort industry in Hunter. Passengers from New York City could reach the Mountain Top without taking the stagecoach up the steep road from Palenville. The lumber and furniture industries also benefited from the railroads.

In 1914, local photographer John Rusk documented a major road-building project on the west end of Hunter on Sand Bank Hill. The steam shovel pictured here is a Thew automatic shovel. Thew products were used in building the Panama Canal. It is interesting to see this steam-powered shovel working alongside two horse-drawn dump carts and a water cart, a sign of changing times.

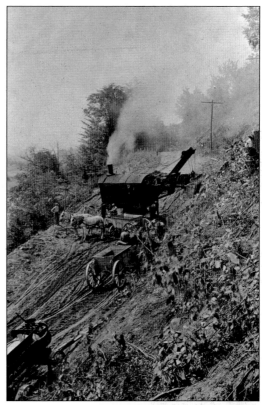

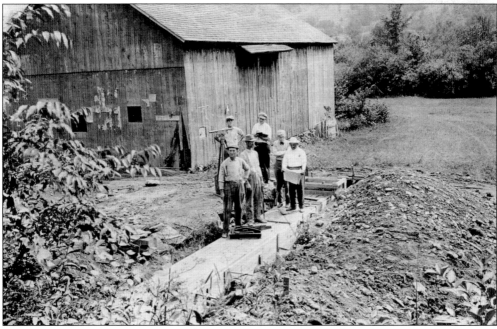

This group of project surveyors is taking measurements to site the culvert forms for the Sand Bank Hill road project in 1914. One man is reading the plans; another is checking the site using a transit.

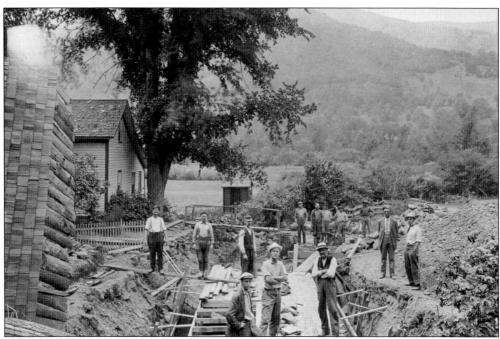

Workmen on the Sand Bank Hill road project are building and setting forms for culverts. One of the workers is D.W. Fisher.

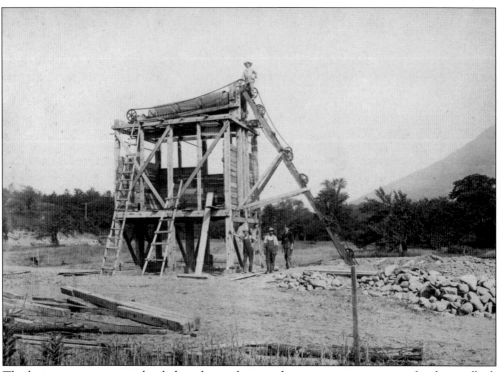

The huge stone sorter was hauled to the worksite and set up to prepare stone for the roadbed. This one was part of the Sand Bank Hill project.

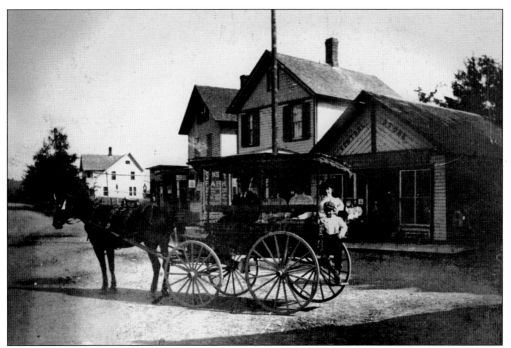

Passengers are waiting aboard a horse-drawn taxi taking them to the Antlers, a large hotel on North Lake Road. The hamlet of Haines Falls at the west end of Kaaterskill Clove had several buildings, including the Central Store, to serve the needs of tourists in about 1905.

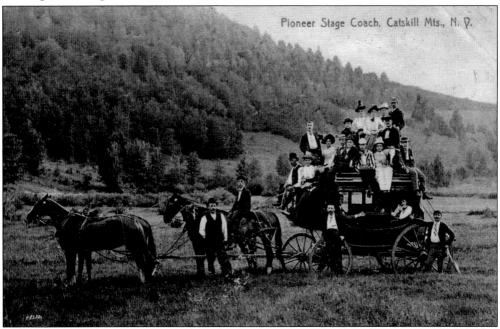

Prior to the railroads, the stagecoach was the primary means of transportation for tourists visiting the hotels around Hunter. Three coaches a week were scheduled through the Kaaterskill Clove to Haines Falls in the mid-1820s. Passengers aboard the stagecoach on the Sleepy Hollow route would sometimes have to walk to relieve the horses during the arduous climb. (Courtesy of GS.)

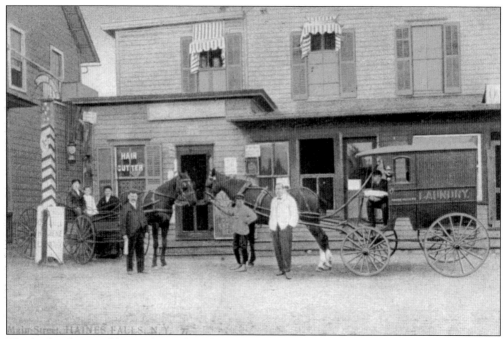

The barbershop and horse-drawn laundry-service truck stand on Main Street in Haines Falls, ready to serve tourists and locals alike, about 1908. (Courtesy of GS.)

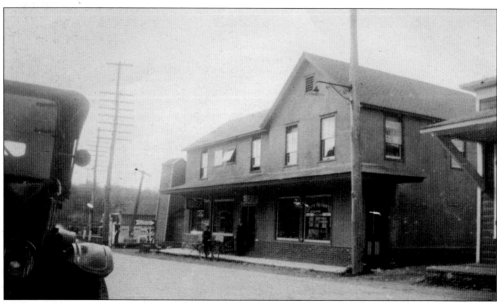

This building on the north side of Main Street in Haines Falls has a photographer's shop with a big window, pictured in this view looking west in the 1920s. The building is still standing and in use as of 2015.

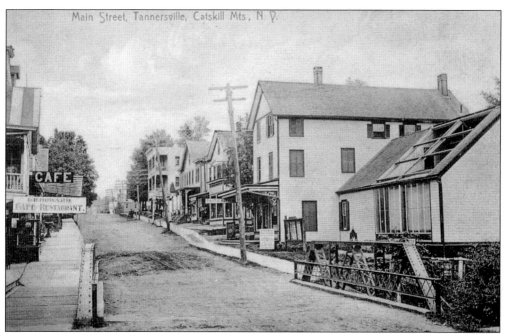

This photograph from 1910 shows Main Street in Tannersville on the Rip Van Winkle Trail about 1.5 miles west of Haines Falls. The large building on the right with skylights is Bickelmann's Photography Studio. The studio is on the south side of the street in this view looking east. This building, 6023 Main Street, is currently the Tannersville Laundry. (Courtesy of GS.)

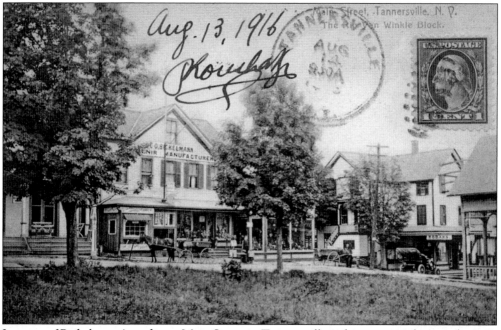

Just east of Bickelmann's studio on Main Street in Tannersville is this souvenir shop run by C.O. Bickelmann. The store was located in the block called the Rip Van Winkle Block in 1916. As tourism boomed in the late 1800s and early 1900s, photographers and souvenir shops were front and center on the main streets throughout the town of Hunter. (Courtesy of GS.)

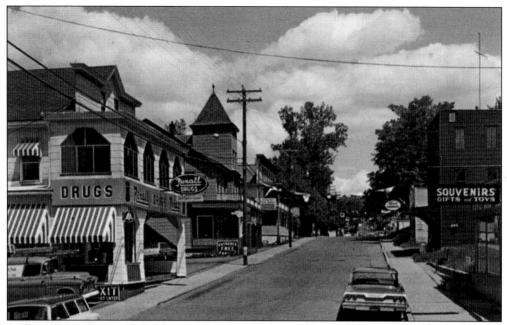

In this 1964 image, the Rexall drugstore is across the street from Bickelmann's Souvenirs (later Rip Van Winkle Bazaar) on Main Street in Tannersville. Rip Van Winkle Bazaar still sold souvenirs in the 1960s, but many of the boardinghouses that brought the tourists were gone by that time. The former Rexall is now the Catskill Mountain Country Store, working to serve a new wave of tourists around Hunter. (Courtesy of GS.)

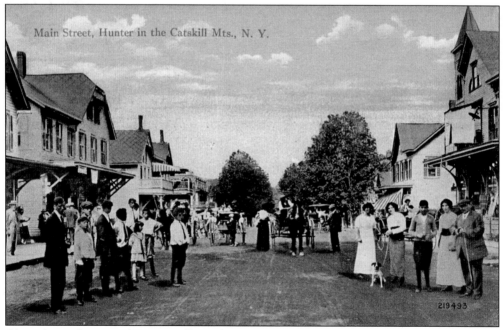

About four miles west of Tannersville on the Rip Van Winkle Trail is the village of Hunter. The scene is filled with people (mainly tourists), shops, and horse-drawn carriages. The time is the late 1800s to early 1900s. (Courtesy of GS.)

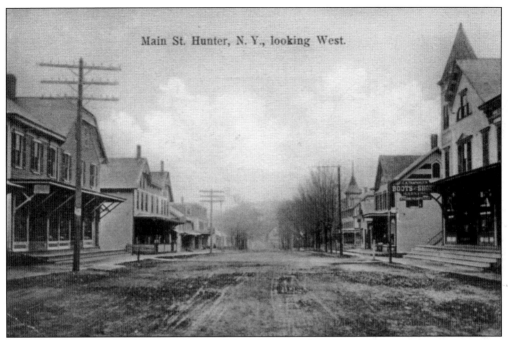

This street scene from about 1908 features Main Street in the village of Hunter in a view looking west toward a leather shop owned by C.A. Traphagen. The shop sold boots, shoes, and harnesses and promised that repairs would be promptly done. (Courtesy of GS.)

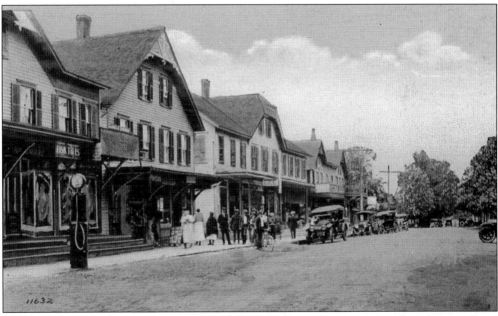

In this photograph of Main Street from about 1912, the horse-drawn carriages have been replaced by automobiles. The gasoline pump in the foreground on the left has been added along with a sign advertising Fisk Tires; otherwise, the scene is little changed from those in the earlier photographs. (Courtesy of GS.)

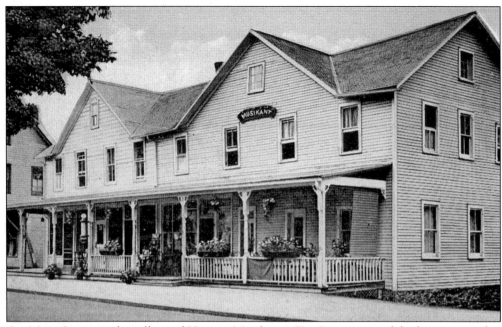

On Main Street in the village of Hunter, Musikant's Tea Room opened for business in this charming building complete with seating on the front porch among the flower boxes and hanging plants. (Courtesy of GS.)

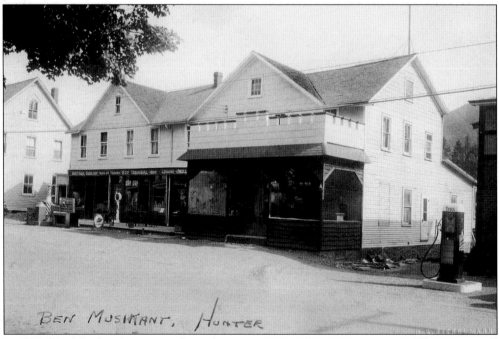

BEN MUSIKANT, HUNTER

In 1937, Ben Musikant's was transformed into a one-stop shopping experience. There were still a table and chairs on the porch, but the services and products available inside included a beauty parlor, barbershop, bus terminal, newspapers, magazines, cigars, and cigarettes. There was also an outdoor sign advertising ice cream. This photograph was taken by H.G. Bickelmann from Tannersville. (Courtesy of GS.)

In 1940, Musikant's underwent another major change, becoming Musikant's Restaurant and Tap Room. Many of the old buildings along the Rip Van Winkle Trail have undergone similar changes over the years. There are treasures to discover beneath many facades; others have been changed beyond recognition. (Courtesy of GS.)

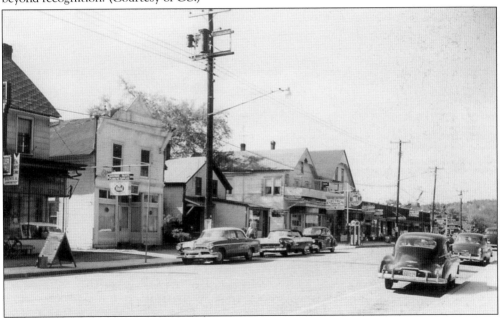

In the mid-1950s, in this view looking west on New York State Route 23A, there are some buildings that were there in the early part of the century and some major changes. The low brick structure (E.A. Ham Building) just to the right of center on the south side of the street houses the post office, Schumann's Drugs, the Hunter Theater, and Sturtz Market. It was constructed in 1933 to replace a block of buildings, including the post office and village hall that burned down in 1932. (Courtesy of GS.)

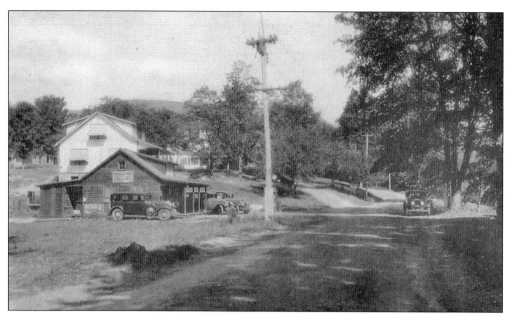

The hamlet of Lanesville in the town of Hunter is not along the main east-west road. The road through Stony Clove is New York State Route 214, which runs south from New York State Route 23A to New York State Route 28 in the town of Phoenicia in Ulster County. Lanesville has its own post office and a small settlement along the road. It also had a train station on the Ulster & Delaware Railroad and several large boardinghouses. The photograph above shows Harry Smith's Tavern and Service Station in the early 1900s. The photograph below is a 1948 view of the road through Stony Clove in winter, illustrating how narrow the road remained well into the 20th century. (Both, courtesy of GS.)

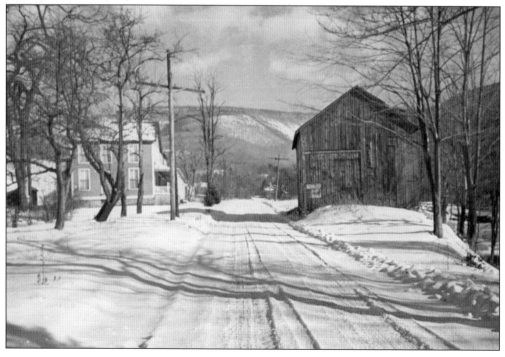

Three

EARNING A LIVING

The challenges faced by the settlers in the area around Hunter were the same challenges that pioneers encountered wherever they chose to settle. They needed clean water, shelter, food, and the wherewithal to make all the things they needed to be safe and comfortable in their new surroundings. The short growing season and harsh winters on the Mountain Top were certainly challenging. The people who moved to this area were hard workers dedicated to making a living and a life in this beautiful place. They found ways to supplement their livelihoods. Much of the work available to them was very difficult, but they were not daunted. They worked in the tanneries, in the forests as loggers and bark-peelers, in the sawmills, in the gristmills, and in the woolen mills. They hauled hides up the mountain to be tanned and then hauled tanned hides back down the mountain to be sent to New York City. They worked in the furniture factories. They cut and hauled rock from the quarries. They built roads for cars and rails for trains. They built houses and hotels. They ran livery stables for visitors. They were conductors and engineers on the railroads. They serviced automobiles. They took in boarders to supplement their incomes. They harvested ice and made maple syrup. They worked as cooks, waiters, housekeepers, and gardeners in the hotels and boardinghouses. They opened restaurants, cafés, and shops. As the times changed, they found new opportunities. They did whatever they needed to do to support themselves and their families.

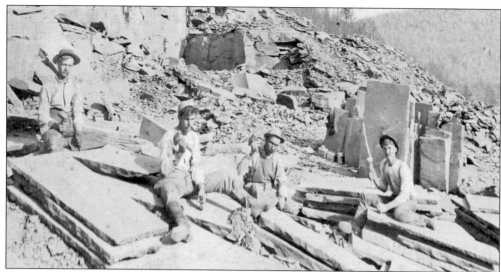

These men are working in a quarry owned by Pete and Uriah Haines located in an unlikely spot, on Prospect Mountain near Sphinx Rock. By the early decades of the 20h century, there were eight operating quarries around Kaaterskill Clove. The loads of stone hauled out of these quarries were taken to the Ulster Bluestone company in Malden, New York, in Ulster County. There were many additional quarries in Platte Clove.

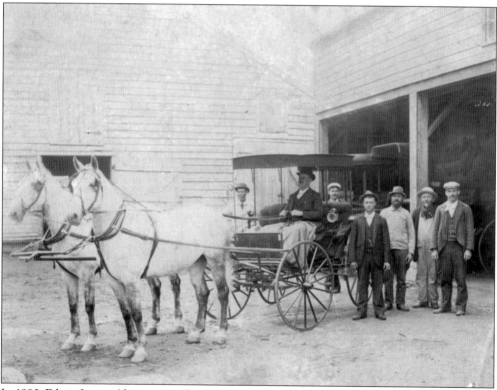

In 1890, Edwin Lewin (the man on the extreme left) and his workers provided transportation for the guests at the Catskill Mountain House. The team of horses pictured here at the Mountain House Stable was driven by Lewin for 31 years.

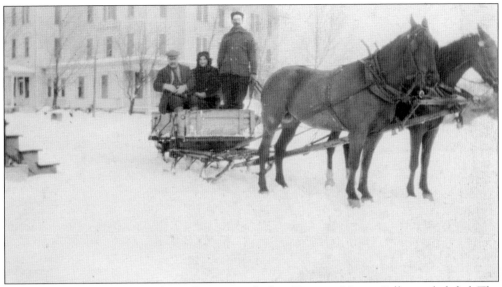

In the winter, horses were used to pull guests at the Lox-Hurst on Haines Falls on a bobsled. The driver pictured here is Henry Myer in 1920.

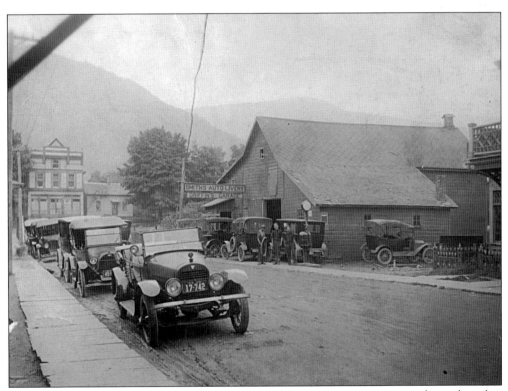

As the 20th century proceeded, fewer horses were used for transporting tourists and more horseless carriages were in evidence. Smith's Auto livery and Griffin's Garage on Bridge Street in the village of Hunter were standing ready to meet the needs of these new vehicles.

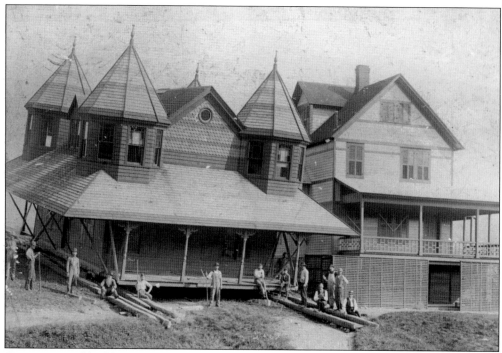

Carpenters and builders in the area around Hunter worked on constructing houses in Onteora, Elka, Twilight, Sunset, and Santa Cruz Parks, as well as the many hotels and boardinghouses that were becoming the major economic engine for the area. These two photographs show those same workmen moving one of those large houses. House-moving of this kind was not uncommon in the early 20th century. The moving was done with manpower, teams of horses, and logs for rolling that were hewn from tree trunks. Two other notable moves were Fromer's barn and the Tannersville synagogue. The latter was moved from west Main Street to Tompkins Street. These hardy pioneers were able to meet the challenges of the time and place.

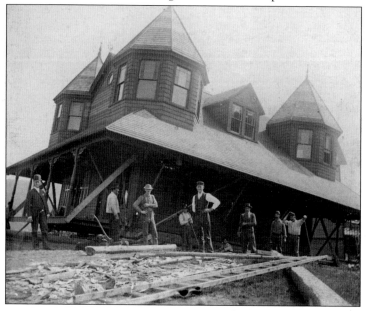

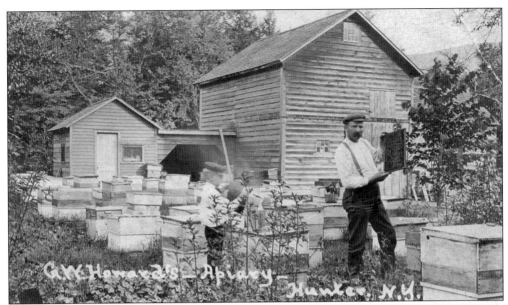

For farmers looking for ways to supplement their food supplies, as well as their incomes, beekeeping was one way to accomplish those goals. G.W. Howard of Hunter is pictured here preparing his hives for the summer in 1907. (Courtesy of GS.)

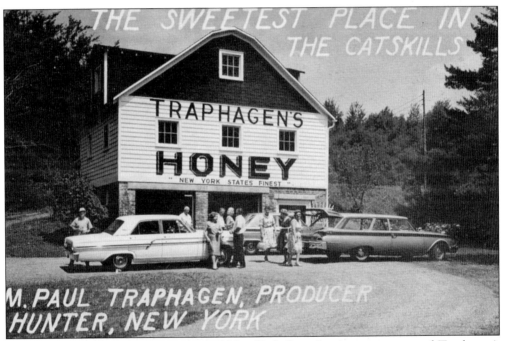

Paul Traphagen, a Hunter carpenter and New York State bee inspector, opened Traphagen's Honey in 1948 on New York State Route 23A, west of the village of Hunter. In 1977, Traphagen sold his roadside business to Lou Schmidt. Schmidt married Fritzie Martin in the 1980s, and they began expanding the product line of the shop. Traphagen's is still a must-see stop for 21st-century travelers to Hunter. (Courtesy of GS.)

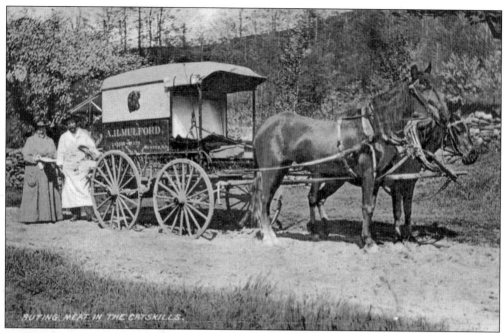

In 1907, Hunter-area residents could buy meat for their families without going to the butcher's shop in town. Local butcher A.H. Mulford delivered meat packed in ice in a horse-drawn wagon to all corners of the town of Hunter. (Courtesy of GS.)

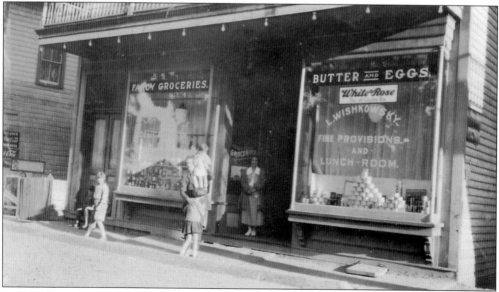

In 1920, fine provisions, butter and eggs, fancy groceries, Red Rose tea, and a lunchroom were all available on the south side of Main Street in Tannersville at L. Wishkowsky's store. (Courtesy of GS.)

The Victory Market was opened in the brick structure on the north side of Main Street in Tannersville that was built on the corner of County Route 23C after the Martin Hotel was demolished in 1927. The hotel had occupied that place under a series of owners since it was built by Harlow Perkins in 1820.

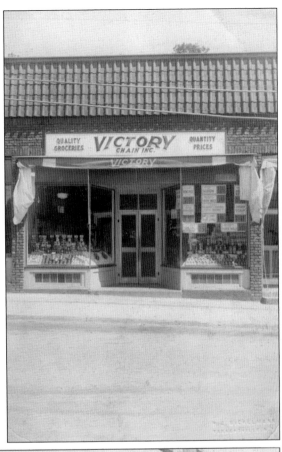

Joseph Brothers Grocery was in Tannersville on the north side of Main Street when this photograph was taken in 1938. The building had been owned by Charles Gray. Later, the second owner of the building, Louis Allen, ran a plumbing-supply business alongside the grocery store. The structure at 5950 Main Street now houses Twin Peaks Coffee & Donuts. (Courtesy of GS.)

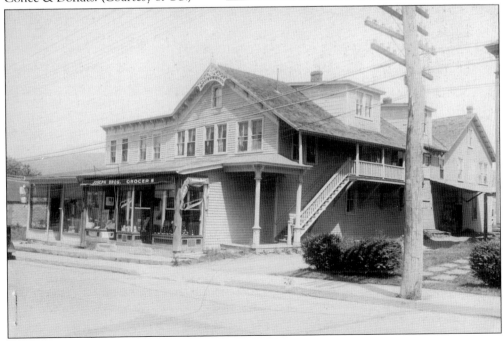

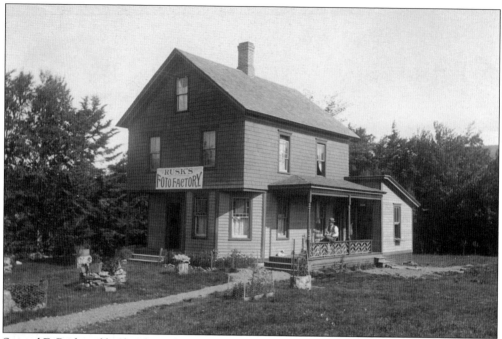

Samuel E. Rusk and his brother John W. Rusk maintained a portrait studio in Haines Falls, Rusk's Foto Factory. Samuel published a guidebook for hiking around Hunter in 1879 and was a member of Arnold Henry Guyot's scientific survey of the Catskills in 1880. He built the Lox-Hurst in 1894, the Claremont in 1905, a post office in Haines Falls in 1907, and served as postmaster in the early 1900s. He published monochrome postcards using his photographs.

Photographer John W. Rusk is pictured here seated on the mule that carried him and his equipment around Hunter. The large-format camera that Rusk is carrying may be one key to the high quality of his landscape and portrait photographs that are now in the collection of the Mountain Top Historical Society. The exceptional care taken by professional photographers in preparing the images allows portions to be enlarged to show details.

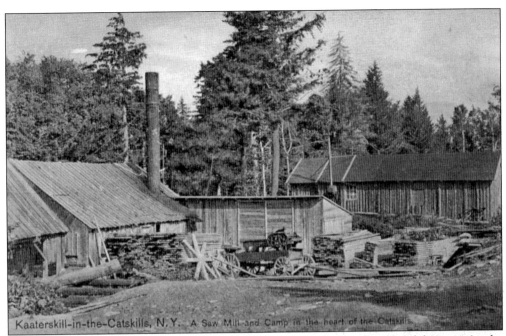

Kaaterskill-in-the-Catskills, N.Y. A Saw Mill and Camp in the heart of the Catskills.

The earliest sawmills in Hunter were small, built to meet the needs of local farmers. As the tannery business waned and the hardwood industry grew, the sawmills became a larger feature in the area. They were moved as stands of trees were logged out. Fire and floods were hazards that often necessitated the rebuilding of a mill, sometimes in a new place. (Courtesy of GS.)

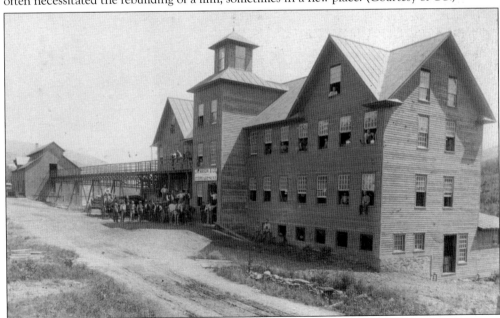

Chairs were the principal product of the woodworking industry in Hunter. Around 1846, George Fromer set up a chair factory on the west end of Hunter. He later sold the business to Lockwood and Chamberlin. Chamberlin sold his share to J.W. Mason and Company of New York City. Mason constructed a new building, powered by a large steam engine. This was the largest chair manufacturer in the area.

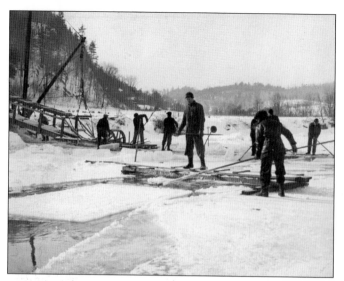

Before mechanical refrigerators were in common use, iceboxes or icehouses with ice harvested from ponds, lakes, and rivers were a necessity for keeping food from spoiling. Hunter's long, cold winters were just right for producing a good crop of ice. This view shows men harvesting ice on Elmer Pelham's man-made pond in Haines Falls along the Ulster & Delaware rail line in the 1920s.

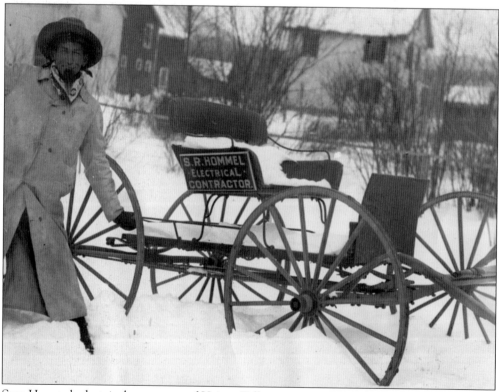

Sam Hommel, electrical contractor of Haines Falls, was a pioneer in the 1920s. He followed in the footsteps of a group of Tannersville businessmen who established the Tannersville Electric Lighting, Power, and Heating Company. The group, led by Jacob Fromer, purchased property west of Tannersville on the Schoharie Creek for a dam in 1904. The water-powered generators brought the first electric lights to the town of Hunter.

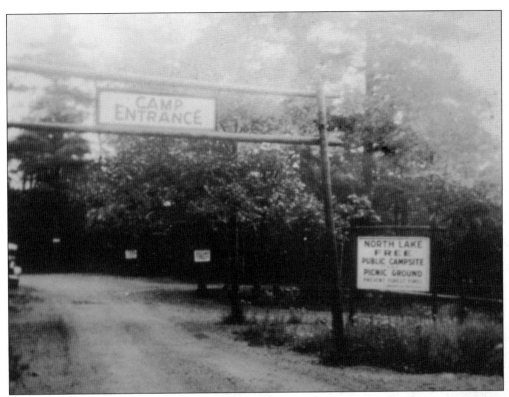

The campground at North-South Lake was first developed as North Lake Campground on Catskill Forest Preserve land in 1929. The original campground had 10 campsites and a small picnic and day-use area. In 1933, there were 33 more campsites added as well as an expanded picnic area. The beach at North Lake was added in 1936. Further expansions brought the number of campsites to 219 in 1972. After South Lake was purchased, a second day-use area was completed in 1984. The narrow isthmus between the lakes was removed and a dam built at the outlet of South Lake, creating one large lake. These two photographs show the entrance to the campground and the ranger's cabin in 1935. The New York State Department of Environmental Conservation continues to provide full- and part-time employment at North-South Lake State Park. Camping is no longer free.

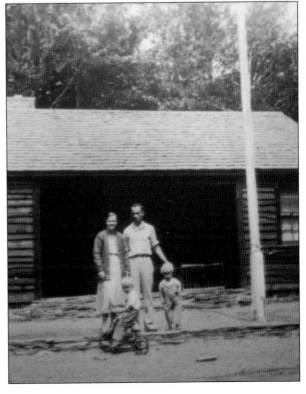

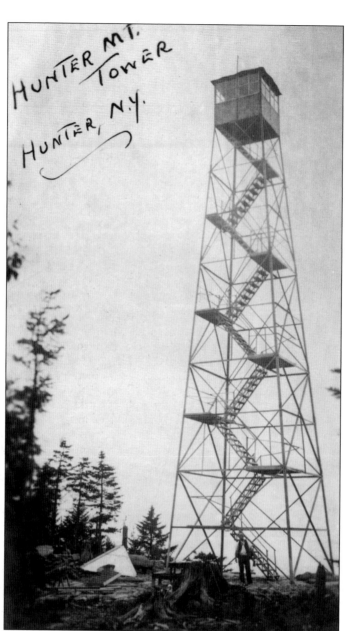

HUNTER MT.
TOWER
HUNTER, N.Y.

The Hunter Mountain Fire Tower has the unique distinction of being the highest fire tower in New York State. As a 60-foot tower atop a 4,040-foot mountain, it has a terrific vantage point. It is one of only a few fire towers that are listed in the National Historic Lookout Register as well as in the National Register of Historic Places. The original wooden tower (40 feet tall) from 1909 was replaced by a steel tower in 1917. That tower was placed at an elevation of 4,000 feet and moved to its present site on the actual summit of Hunter Mountain in 1953. New York State officially closed the Hunter tower in 1989. The last observer was local resident Bill Byrne. Fortunately, a group of citizen volunteers organized by Bo Ripnick worked with state employees to repair and reopen this special place in Hunter history. During the summer months, volunteer interpreters are available at the Hunter Fire Tower to guide the hikers who make the climb to the Hunter Mountain summit for the view.

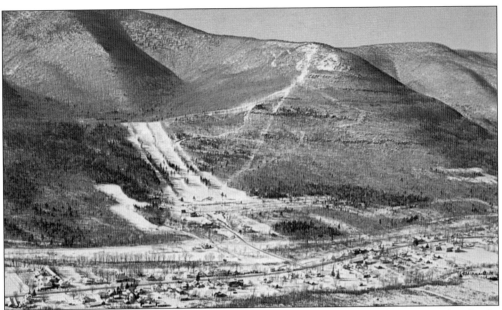

Hunter Mountain Ski Bowl, on the north side of Colonel's Chair, first opened in 1960. The Slutzky brothers, Israel and Orville, in an effort to boost the sagging economy in Hunter, organized a group of investors to back the ambitious project. I. and O.A. Slutzky Construction Company did the building. The first two years were difficult. When the development group declared bankruptcy, the brothers took over the business beginning in 1962. By continually improving trails, lifts, snowmaking, ski school services, and lodge facilities, the Slutzky brothers and their families have made Hunter Mountain Ski Bowl a major economic force in the town of Hunter. There is even an effect on warm-weather tourism, as Hunter Mountain is the venue for music festivals, food and beer festivals, weddings, and the Skyride. The aerial view above is from 1959; the lifts opened in 1960. (Both, courtesy of GS.)

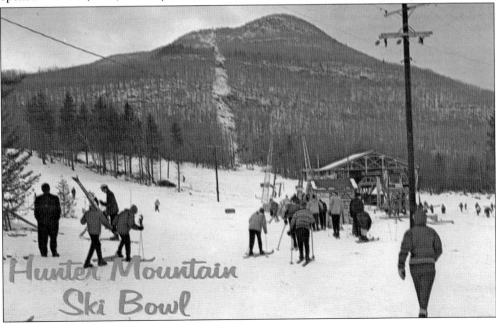

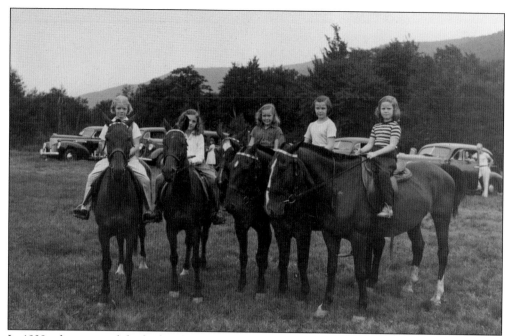

In 1939, after automobiles had replaced horses on the roads around Hunter, there was still a call for the riding lessons provided at Elmer and Fred Pelham's Kenwood Riding Academy in Haines Falls. In 1924, at the urging of Susan Eltinge Underhill, Fred bought three saddle horses—Brownie, Gypsy, and Kit—to start the academy. The students in the photograph above are, from left to right, Anne Breckwoldt, Babs Hawley, Barbara Bieber, Joan Dunne, and Joan Lee. In the photograph below, the student riders are, from left to right, Gene Hoffman, Thomas Walker, Robert Dunne, John Walsh, Jerry Hoffman, Patrick Verilli, and Dalton ?

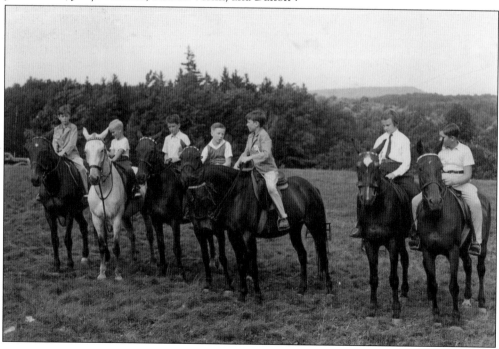

Four

BOARDINGHOUSES, RESORTS, AND RAILROADS

Boardinghouses, hotels, inns, and resorts were a major part of the Hunter economy throughout the 19th and 20th centuries. There were over 120 places to stay in Hunter, ranging from farmhouses to grand hotels. The earliest hostelry in Hunter is likely Perkins Inn, built in 1820 at the Four Corners in Tannersville. Perkins Inn went through a number of owners before being demolished in 1927. Additionally, farmers in Hunter had begun taking in itinerant workers such as bark-peelers and loggers in the early days of the 19th century as a means of supplementing their income. It was an easy next step for them to cater to families who wanted to escape the oppressive summer heat in New York City. The farms provided fresh air, clean water, milk, and vegetables to their guests. The first grand hotel, the Catskill Mountain House, was opened in 1824 on the promontory named Pine Orchard. It had the view of the Hudson River Valley that Thomas Cole and other Hudson River School painters made world-famous. Tourists began making the difficult journey from Catskill on the Hudson by stagecoach to the Mountain Top. Additional boardinghouses began springing up to receive the overflow from the Catskill Mountain House. The next grand hotel on the Mountain Top was the Laurel House situated at the top of Kaaterskill Falls, in 1847. Then the Hotel Kaaterskill opened in 1882, the same year that the Ulster & Delaware Railroad made its initial run through Stony Clove to Kaaterskill Junction in Hunter. The railroad made the trip from New York City to the Mountain Top faster and easier. From Kaaterskill Junction at the north end of Stony Clove, the trains went east through Tannersville to Haines Falls and west into the village of Hunter. The post–Civil War era was the height of the tourist industry in Hunter, with people filling boardinghouses, hotels, and inns.

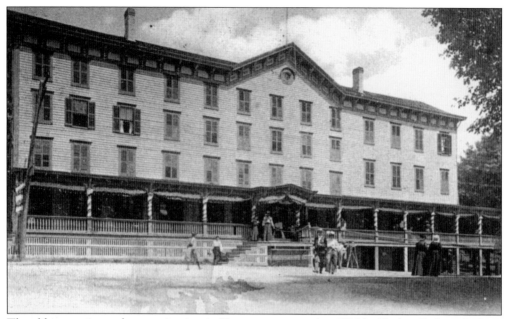

The oldest continuously operating inn in Hunter was opened in 1820 by Harlow Perkins. Perkins sold the Perkins Inn to Norman Gray in 1850. After Gray's death, his son sold to Roggens in 1869. Sohmers owned the hotel from 1897 until he sold in 1902. William B. Martin operated it as Martin's Hotel until the structure was demolished in 1927. The hotel was at Tannersville Four Corners, where County Route 23C intersects State Route 23A.

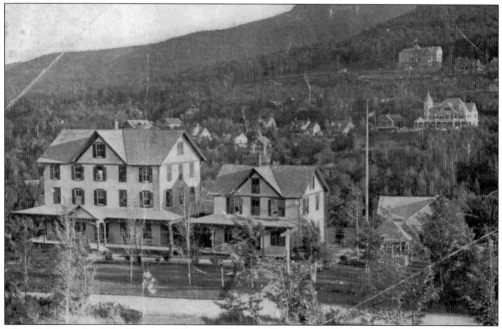

This photograph of the Kenwood, built by Elmer Pelham in 1898 on the Rip Van Winkle Trail, shows Twilight and Sunset Parks to the south. The Kenwood was located approximately across the street from the Lox-Hurst, the present site of the Mountain Top Historical Society at 5132 State Route 23A in Haines Falls.

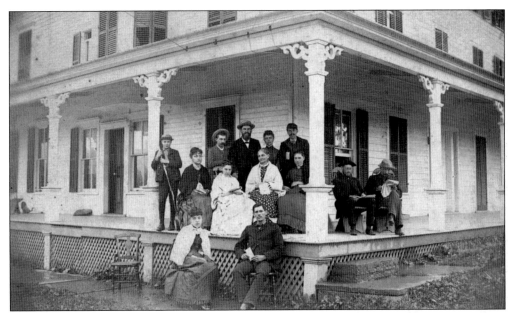

Visitors are relaxing on the porch of the Haines Falls House around 1890. Charles W. Haines built the hotel in 1864 near the western end of the Kaaterskill Clove Road and close to the place where Haines Falls drops into the clove, a very scenic spot. The hotel did well until it burned down in 1911.

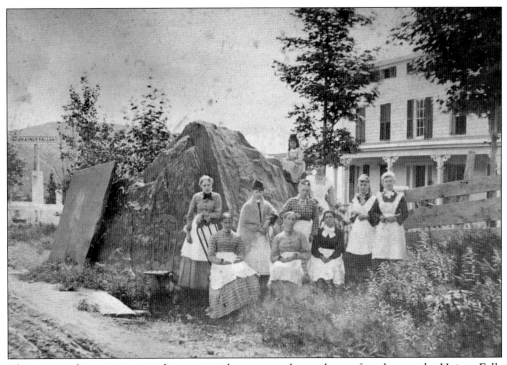

This group of nine women and a young girl appears to be made up of workers at the Haines Falls House. The photograph is dated 1882. The young girl seated on the rock is identified as Jennie E. Haines, daughter of the owner, Charles W. Haines.

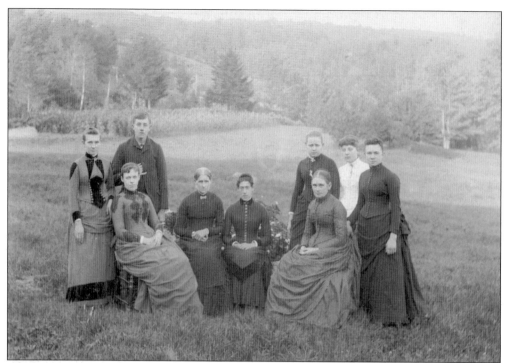

This is another photograph of the help at the Haines Falls House prior to 1890. Elida Fatum Pelham is seated third from the left. Adeline Blight Haines (wife of the owner, "Christian Charlie" Haines) is the first woman seated on the right. The young man is Adam Pelham.

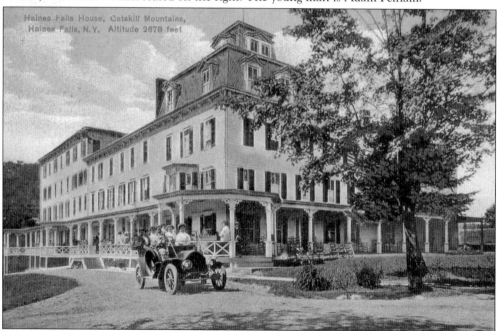

Haines Falls House, Catskill Mountains, Haines Falls, N.Y. Altitude 2678 feet

Over time, Charles Haines made additions to the Haines Falls House. This is a postcard photograph of the facade from about 1910, as automobiles are making their way to the Mountain Top. (Courtesy of GS.)

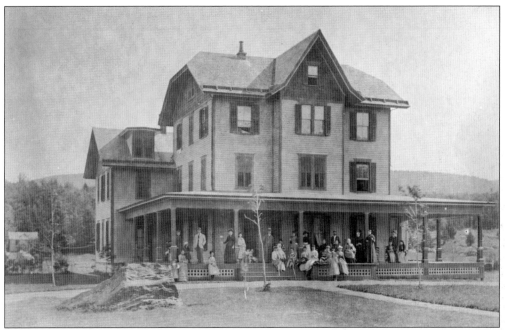

The Lox-Hurst is one of the many boardinghouses that dotted the town of Hunter. It was originally built in 1884, with an addition made in 1893. The Lox-Hurst survived into the mid-1960s as La Cascade, with the addition of a fine French restaurant by owner Paul Dumas. In the 1980s, it became Hunter Mountain Resort Ranch, a dude ranch that burned down in the 1990s.

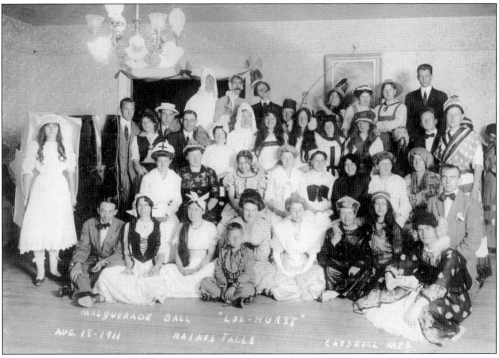

In addition to the outdoor activities enjoyed by the summer visitors to the Lox-Hurst were escapades such as this masquerade ball from 1911.

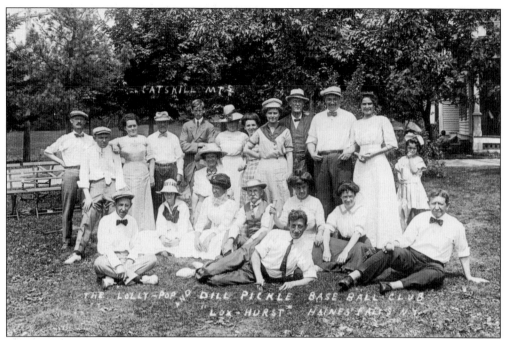

The Lolly-Pop and Dill Pickle Baseball Club at the Lox-Hurst in the early 1900s is a merry group of men and women ready to enjoy a game together in the clear mountain sunshine. The woman in the center front of the group is holding the baseball bat. The young girl on the right looks a bit unsure about what these adults are up to.

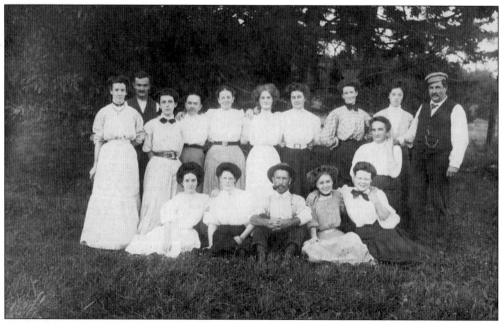

On the back of this 1905 photograph of the employees of the Lox-Hurst, only one person is clearly identified. Chris Martin is the man on the right. Three other identifications are noted without attribution to a specific person: ECL, Jennie Mackey Pond, and Edna Mackey Lackey.

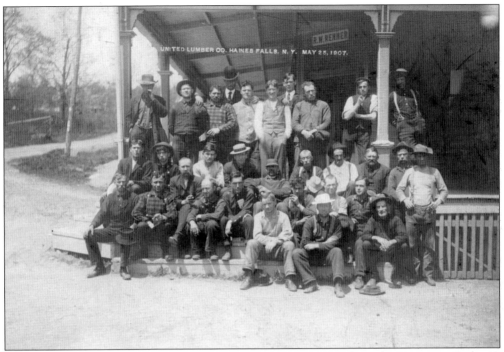

In May 1907, Renner's Mountain Inn hosted this group from United Lumber Company. Renner's was a year-round hotel and tavern serving local trade as well as travelers. It was originally built by W.I. Hallenbeck in 1878 at the intersection of North Lake Road and State Route 23A. The business was purchased by R.W. Renner in 1903.

In the 1920s, automobiles were becoming the preferred mode of transportation. In the road alongside Renner's, there was now a sign reminding drivers to "go to the right."

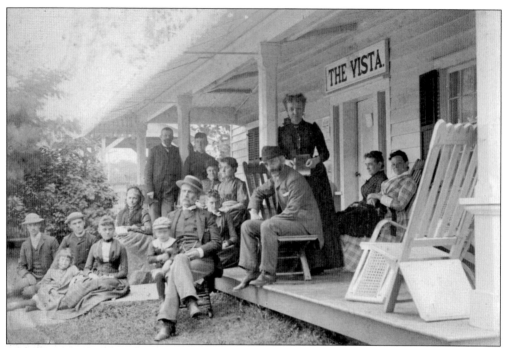

John W. Rusk of Rusk's Foto Factory in Haines Falls was on hand in 1880 to take this photograph of vacationers on the front porch of the Vista, located at 5183 Route 32A, not far from his studio. The oldest hotel in Haines Falls, the Vista was built by Aaron Haines in 1849.

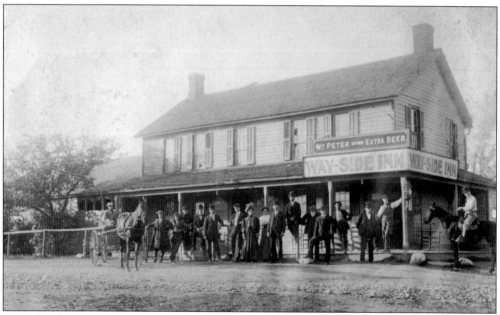

The Wayside Inn was located at the intersection of State Route 23A and County Route 25. In this photograph from about 1890, it looks like a popular spot for meeting with friends and enjoying a beer. Volunteers in the hamlet of Haines Falls have turned the site of the Wayside Inn into a local park with a gazebo where passersby can relax and watch the cars along the road or enjoy a picnic lunch.

With all of the hotels that were right in the heart of Haines Falls and in the surrounding area, the coming of the railroad was a boon. In 1905, when these photographs were taken by Clarence B. Taylor, who was vacationing with his family, there were two railroad stations in Haines Falls. The station in the photograph on the right, Haines Corners, served the Catskill and Tannersville narrow-gauge line that ran from the top of the Otis Elevating Railroad near the Catskill Mountain House through to Tannersville. In the photograph below, people are strolling up State Route 23A to the Ulster & Delaware station near the spot where the rails cross the road.

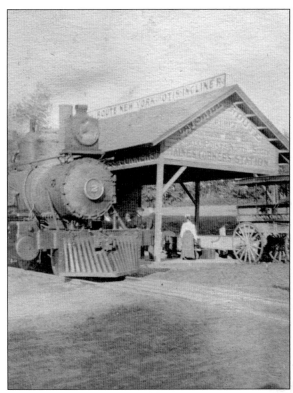

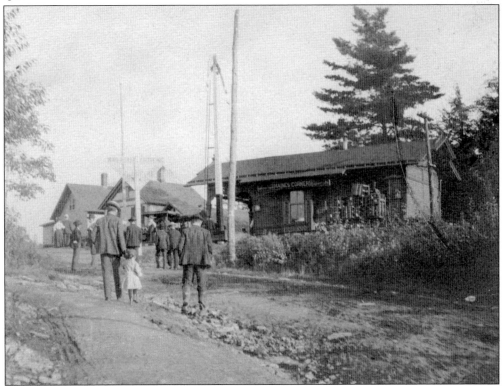

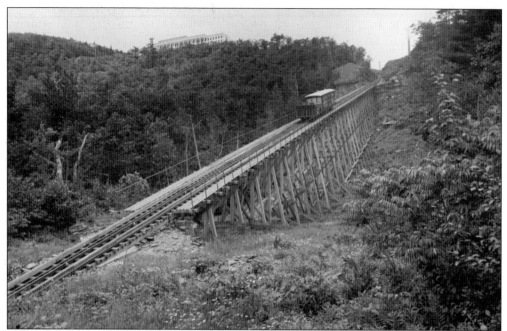

Completed in 1892, the Otis Elevating Railroad, with a rise of 1,630 feet, was the final link in the rail journey from Catskill to the Catskill Mountain House overlooking the Hudson River Valley. It was a first of its kind in the United States. Prior to the opening of this incline railway, passengers heading to the Mountain House boarded a stagecoach in Palenville for a steep and dusty ride. (Courtesy of the Library of Congress.)

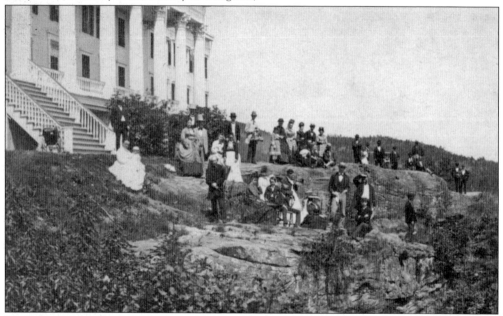

The piazza of the Catskill Mountain House with its 13 distinctive Corinthian columns was the ideal place for looking at the spectacular view of the Hudson River from the escarpment. It was equally impressive to view this famous hotel from the Hudson River. From 1824 until 1963, people traveling through the valley looked up to see this structure.

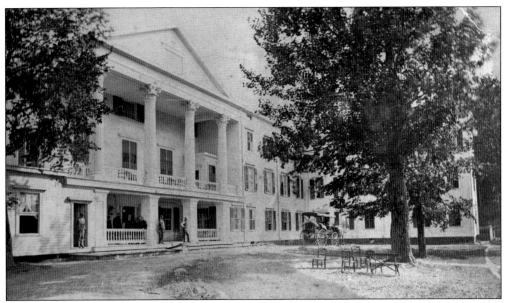

When guests arrived at the Catskill Mountain House in 1895, they would be taken up the curving drive through the stone pillars to the west front of the hotel, opposite the well-known colonnade with the view to the east. They would enter the lobby from there.

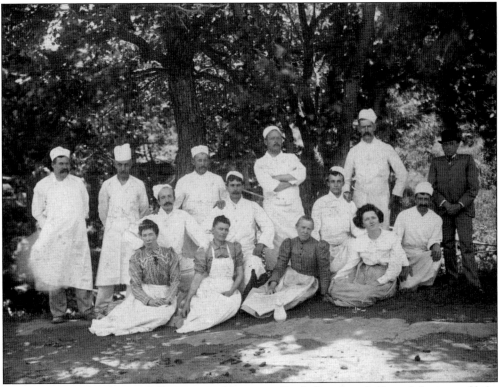

In 1899, the chef at the Catskill Mountain House was Emile Reinfranck (far right), pictured here with his kitchen staff.

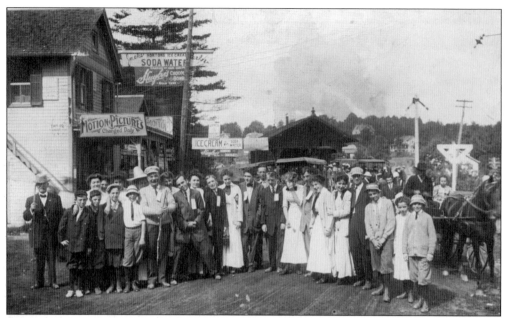

By around 1910, the street scene in Haines Falls was very busy. This photograph shows a jumble of signs for chocolates, ice cream, soda water, motion pictures, a tailor, and a gaggle of people posing for the camera after the departure of the train. There are taxis in the back waiting to take people to their hotels. Abe Legg (with mustache) is driving the wagon on the right; seated beside him is Florence Legg.

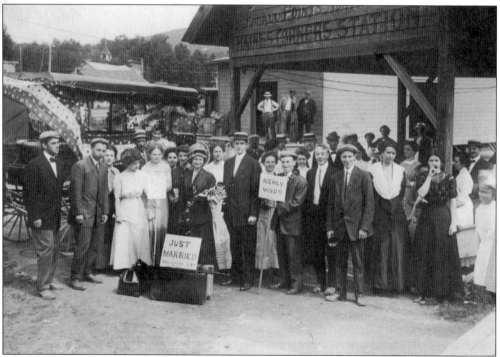

This group of newlyweds is posing at the Haines Corners Station of the Catskill and Tannersville Railroad in the early 1900s, possibly en route to festivities at the Catskill Mountain House.

These women are waiting in Haines Falls for the Ulster & Delaware train around 1890. The building that can be glimpsed through the group on the right side of the photograph is the Central House, at 5243 Route 23A.

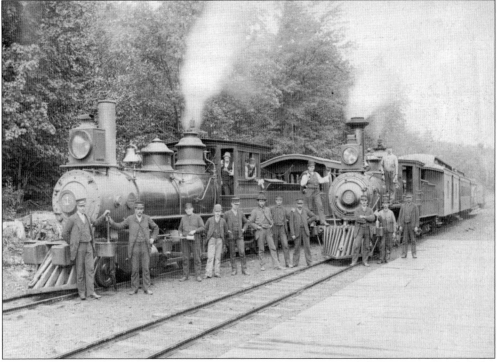

Kaaterskill Railroad engines No. 1 and No. 2 are waiting at Kaaterskill Station at South Lake. Charles Vandermark is second from the right, and Charles Penrose is on the far left. Henry Sherman is standing on the locomotive on the right, and Emery Myer is wearing a derby hat. The others are unidentified. The Kaaterskill Railroad started service to this station in 1882 for Hotel Kaaterskill, the Catskill Mountain House, and the Laurel House.

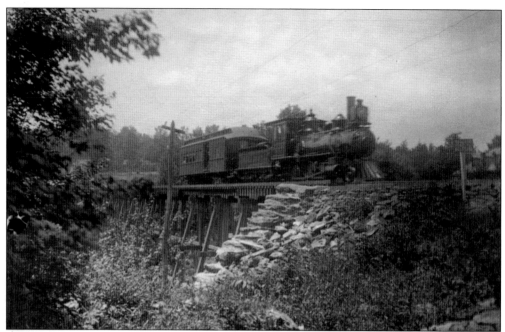

The narrow-gauge Catskill and Tannersville Railroad was nicknamed the "Huckleberry." On its run between Tannersville and the Catskill Mountain House at Otis summit, it kept a more relaxed schedule than other trains. The engineer might slow down to view Kaaterskill Falls and even stop to allow passengers to pick the local huckleberries when they were in season. In this photograph, the Huckleberry is coming into Haines Falls around 1900.

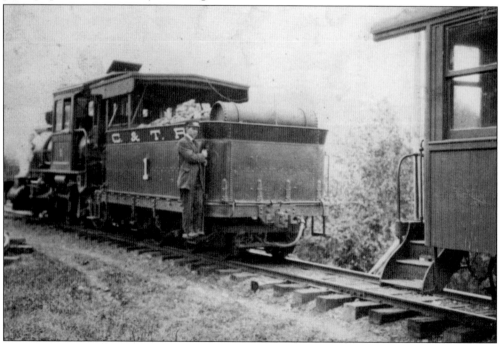

This image shows the Catskill and Tannersville Engine No. 1 at the Tannersville turntable in 1900, preparing for a return run to Haines Falls and the Mountain House.

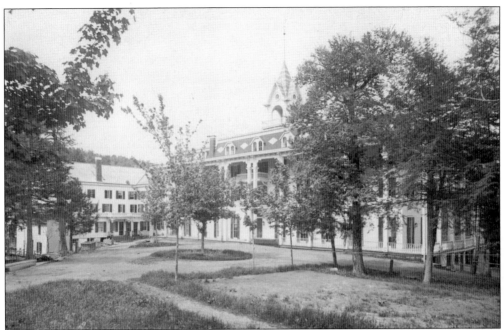

Both the Catskill and Tannersville Railroad and the Ulster & Delaware made stops at the Laurel House on their runs to the Catskill Mountain House and South Lake. Peter Schutt began his business by taking in boarders at his farmhouse and then built a hotel for about 40 guests that opened in 1847. His property included the Kaaterskill Falls and a vista that took in the Kaaterskill Clove and the private parks (Twilight, Santa Cruz, and Sunset) that hugged the opposite wall of the clove. As the tourist boom continued during the post–Civil War era, Schutt made several additions to his hotel until he could accommodate 150 guests. A later addition by his son doubled the number of guests that could stay at the Laurel House. Access to the falls and the clove made the Laurel House very popular.

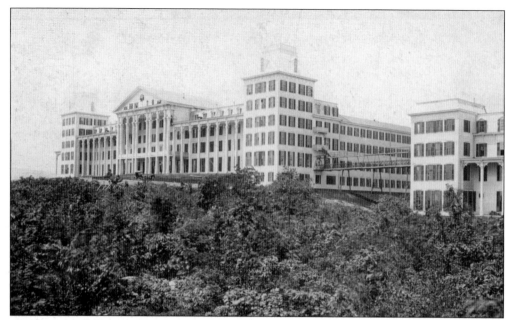

Construction of the Hotel Kaaterskill began in the winter of 1880, and the hotel opened in the summer of 1881. With rooms for 600 guests, Philadelphia patent attorney George W. Harding was in direct competition with Charles Beach and the Catskill Mountain House. He billed his hotel as the grandest and loftiest hotel in America. The Kaaterskill operated on South Mountain from 1881 until it burned to the ground in September 1924.

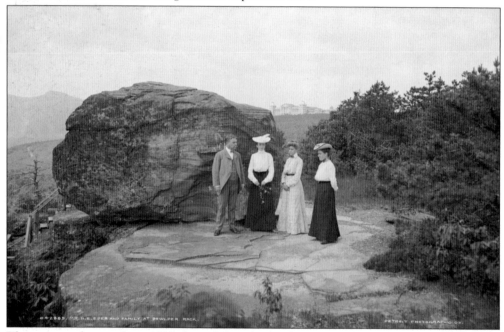

This image, taken in about 1883, shows hikers from either the Catskill Mountain House or the newer Hotel Kaaterskill at a popular spot named Boulder Rock. Boulder Rock is located near the border between the two hotel properties and can be reached today by hiking along the escarpment trail. (Courtesy of the Library of Congress)

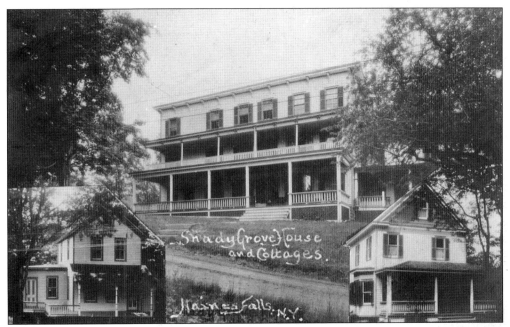

The Shady Grove is an example of a family home that was expanded to take in boarders. The O'Hara family went into the boardinghouse business in 1900. The Shady Grove, located at 54 O'Hara Road in Haines Falls, underwent further expansion through the years under additional owners. This postcard shows the Shady Grove in the 1920s.

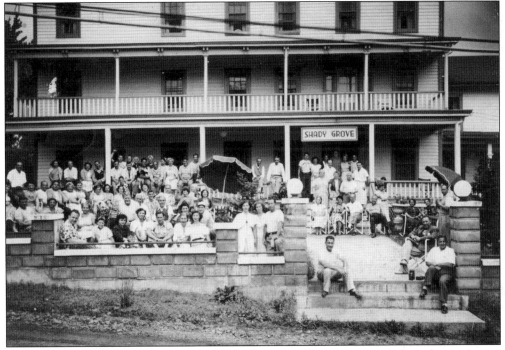

As shown in this August 1950 image, the Shady Grove is still hosting a crowd of people vacationing in Haines Falls. It was part of a large Italian restaurant and hotel for many years before becoming Peace Village, a retreat center for Brahma Kumaris, in 1999.

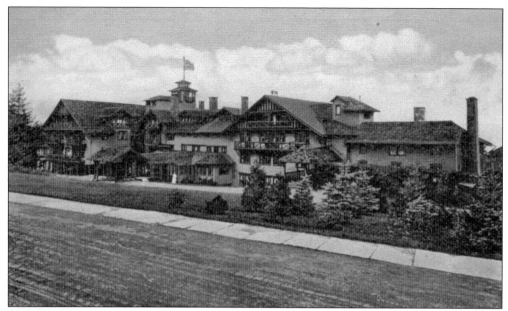

In the early 1900s, Haines Falls was a busy place with hotels, inns, and boardinghouses. The three grand hotels were north of the hamlet near North and South Lakes. There were additional inns built within the private parks in Hunter. The Twilight Inn was constructed in 1888. All of the inns within the parks were for the use of park members and guests.

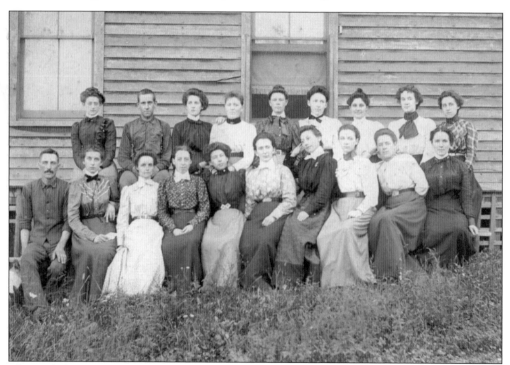

The Twilight Inn provided employment for builders, landscapers, chambermaids, cooks, waitstaff, and maids. The 17 women and two men pictured in this 1899 photograph, all unidentified, are among the hired help.

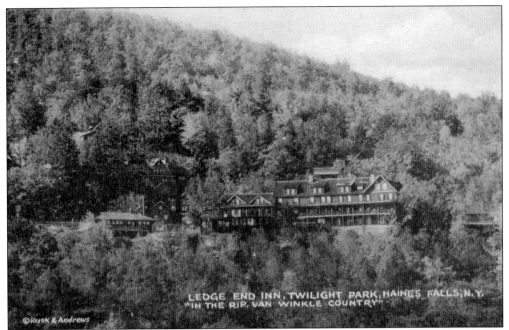

Ledge End Inn in Twilight Park had a commanding view of Kaaterskill Clove in the early 1900s. All of the inns built in Twilight Park reflect the rustic aesthetic typical of the cottages of that era. (Courtesy of GS.)

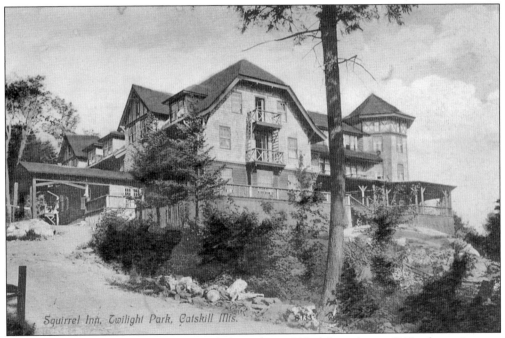

The original Squirrel Inn opened in Twilight Park in 1892. After a fire in 1907, a larger inn was built to replace it. This image shows the larger, rebuilt Squirrel Inn in 1912, which was torn down in 1944.

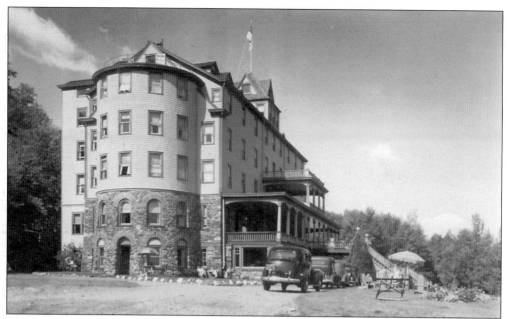

The Sunset Park Inn in the 1930s was a large, imposing building. It was constructed in Sunset Park on the western edge of Twilight Park. After falling into disrepair, the inn was destroyed in a controlled burn around 1990. (Courtesy of GS.)

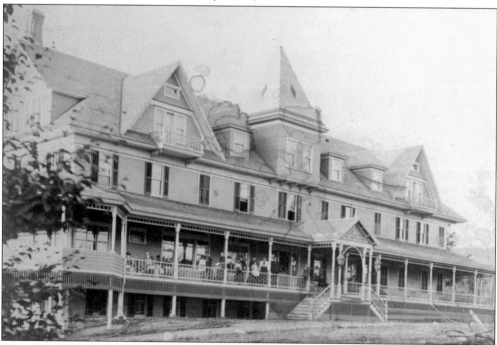

Along North Lake Road (County Route 18) in Haines Falls, there were numerous hotels and boardinghouses ranging from farmhouse style to large and elegant hotels like the Antlers. The Antlers opened in 1892 with a noteworthy view to the south of Kaaterskill High Peak and Round Top seen from its 12-by-200-foot piazza. Advertising for the Antlers boasted of "Guests' Rooms large and airy." It burned down in 1932.

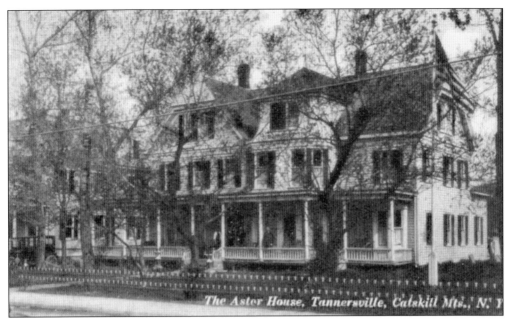

The Aster House, Tannersville, Catskill Mts., N. Y.

Haines Falls had a large number of hotels and inns due to its proximity to Kaaterskill Clove. However, people traveling to the Catskills could also find fine lodging in all of the villages and hamlets in Hunter. The Astor House, at 5980 Main Street, was one of several boardinghouses located on State Route 23A in Tannersville. The building has been rehabilitated by the Hunter Foundation and is now in use as a pharmacy. (Courtesy of GS.)

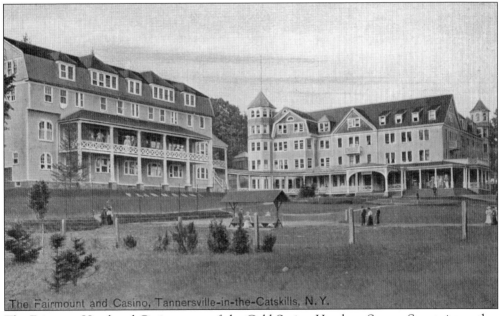

The Fairmount and Casino, Tannersville-in-the-Catskills, N. Y.

The Fairmont Hotel and Casino, west of the Cold Spring Hotel on Spruce Street, is another example of a boardinghouse that grew. It became the largest hotel in Tannersville. The owners gradually added a shingled roof, paint color, turrets, large porches, tennis courts, and a swimming pool. The Fairmont even had an 18-hole golf course with local resident Donald Thorpe as the golf pro. (Courtesy of GS.)

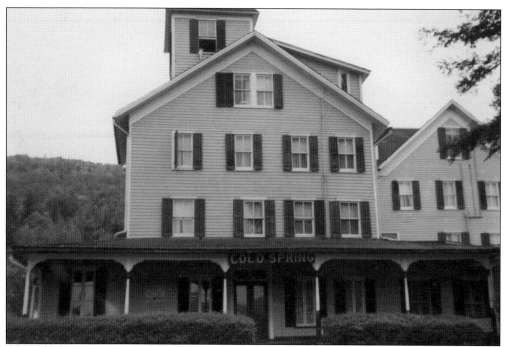

The Cold Spring Hotel, originally called the Gilbert House, was built in the 1890s as the first Jewish hotel and the second-largest hotel in Tannersville. An annex with 20 rooms and a dancing hall was built for the 1902 season. Located at 55 Spruce Street, the Cold Spring Hotel was near a pure mountain spring from which it took its name. Its advertisements promised that the hotel raised its own vegetables and served fresh milk from its own cows. It also advertised plenty of room to relax or play on extensive lawns with fine old shady trees all around. Although the building is still standing, it has been badly neglected and is now scheduled for demolition in 2015. Standing for 125 years, it is the last of the large hotels around Hunter.

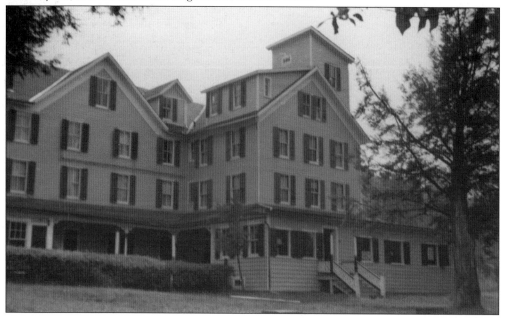

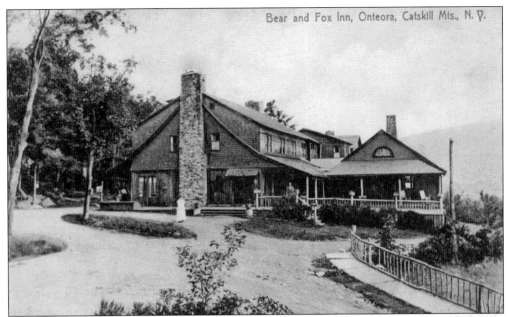

The Bear and Fox Inn was built in Onteora Park in Tannersville in 1887. It provided a place for Onteora Park members to house guests or stay while their own houses were being built. Architect Dunham Wheeler designed the inn in the rustic style common to the park. The inn became the hub of park life, a place for balls, lectures, dramas, and other get-togethers. It is now a private home. (Courtesy of GS.)

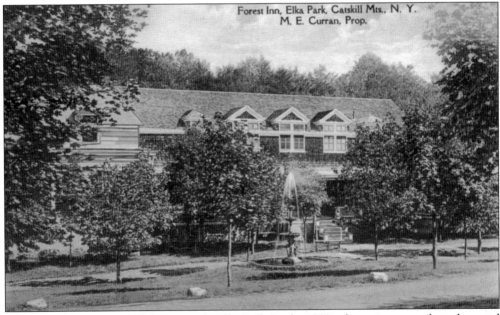

In 1889, the Poggenburgs built a casino in Elka Park. In the 1900s, the casino was enlarged, named the Forest Inn, and managed by Michael and Catherine Curran. The Currans owned the inn from 1918 until selling to their daughter Mary Curran Byrne and her husband, William, in 1957. The Byrnes operated the inn until selling in 1968 to another buyer. In 1974, Byrnes descendants restored the building. It burned down in 1993.

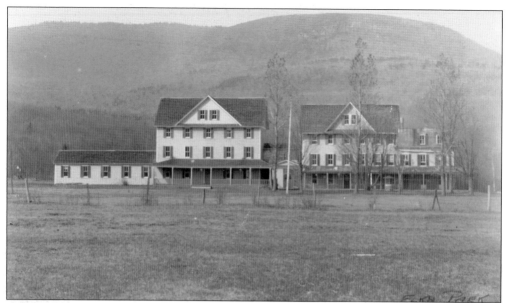

E.M. Dibbell ran the Twin Mountain House on Dale Lane in Platte Clove, 4.5 miles from the Tannersville railroad station. The hotel was surrounded by Catskill High Peaks, including Kaaterskill High Peak to the northeast and the Twin Mountains to the south. The Schoharie Creek was nearby for trout fishing, and Plattekill Falls was about a 30-minute walk to the east. (Courtesy of GS.)

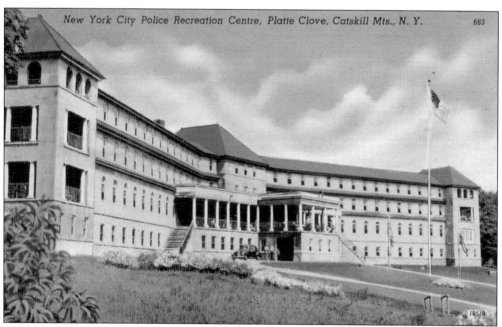

In 1920, the New York City police commissioner acquired 332 acres in Platte Clove from Anna Kaplan to establish the New York City Police Recreation Center. The original police recreation farm became the Indian Head Hotel in 1925 and two years later, the Police Recreation Center. Its purpose was to provide a place to relax from the stress of urban police life. It was closed in 1983 and sold to the Platte Clove Community. (Courtesy of GS.)

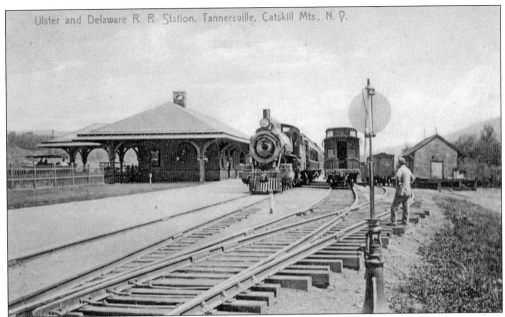

The Ulster & Delaware railroad station in Tannersville, located south of the village at 29 Lake Road, was the hub for visitors to Tannersville, Elka Park, and Platte Clove. The trains arrived as scheduled from the Phoenicia station through Stony Clove and Kaaterskill Junction to Tannersville, where passengers would be met and transported to their destinations. In 1901, transportation was by horse and carriage. (Courtesy of GS.)

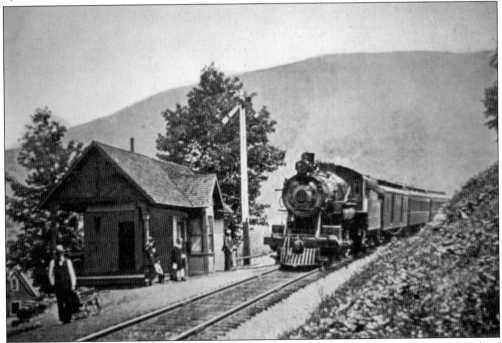

The Ulster & Delaware railroad station in Lanesville was the first passenger stop north of Phoenicia in Stony Clove. Here, passengers were let off to access the boardinghouses in the hamlet of Lanesville in about 1910.

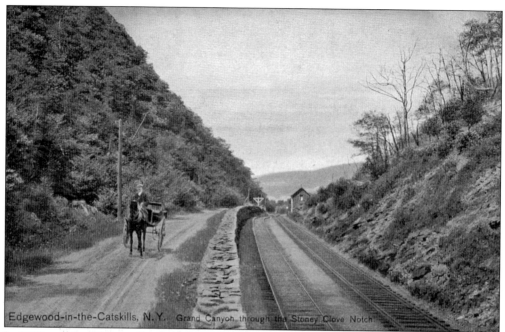

In 1908, north of Lanesville, the Ulster & Delaware trains heading through the Notch (Stony Clove) toward Kaaterskill Junction could pick up and drop off passengers at Edgewood. (Courtesy of GS.)

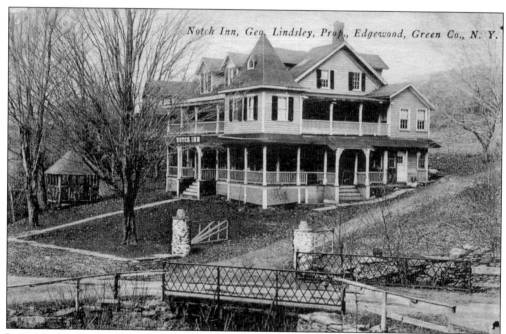

In 1905, the Notch Mountain House hotel was owned and operated by George Lindsley in the smallest hamlet in Hunter, Edgewood. At the time, in the early 1900s, Edgewood had its own post office. (Courtesy of GS.)

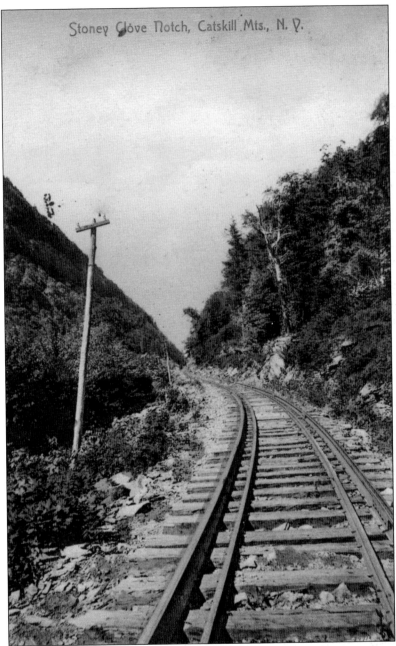

Stoney Clove Notch, Catskill Mts., N. Y.

All of the Ulster & Delaware rail lines through Stony Clove to the town of Hunter were narrow-gauge rails. At a special meeting of the stockholders of the Ulster & Delaware Railroad Company on March 27, 1899, in Rondout, New York, a proposition was passed to change the gauge of the Stony Clove & Catskill Mountain Railroad from narrow gauge to standard gauge. The purpose of the change was to allow the railroad to accommodate the number of cars needed to meet the demand for transportation to the resorts in the town of Hunter as well as handle the needs of the growing furniture and lumber industries. The funds for the change were also authorized, and work began immediately. In this view of the rails through Stony Clove, the new standard-gauge rails straddle the narrow-gauge rails that are scheduled to be taken up.

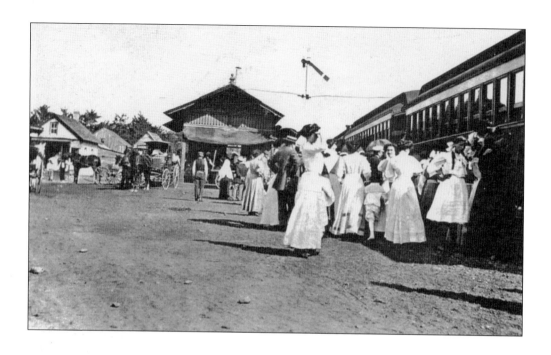

When the Ulster & Delaware Railroad trains reached Kaaterskill Junction, at the north end of Stony Clove, passengers could head east to Tannersville and Haines Falls or west to the village of Hunter. The line ended at the Hunter Station on the west end of the village. As shown in these two images made in the early 1900s, transportation to the village hotels was aboard a horse-drawn wagon. Later, those wagons were replaced by automobiles. (Both, courtesy of GS.)

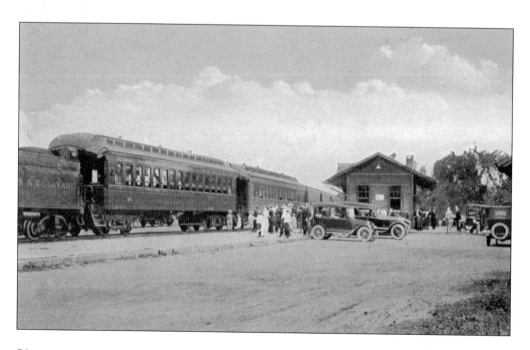

The Notch Mountain House on the east end of Hunter village on Main Street (State Route 23A) offered guests a beautiful view to the south through Stony Clove. This Bob Wyer postcard image was taken in 1949. (Courtesy of GS.)

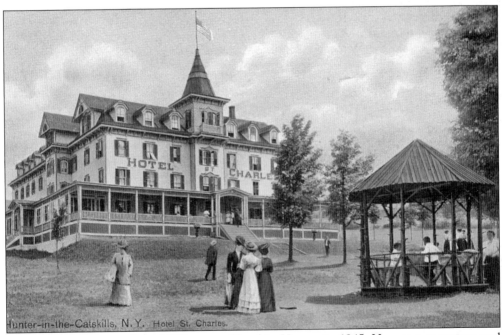

John H. Burtis Sr. purchased 350 acres of land in Hunter in 1845. He was a carpenter and manufactured sieves. He built a home and enlarged it to accommodate summer boarders. The boardinghouse burned down in 1882 and was replaced by a large hotel, named the Breeze Lawn and managed by S.P Van Loan. In 1892, John Burtis Jr. became the manager of the hotel, renamed the Hotel St. Charles. (Courtesy of GS.)

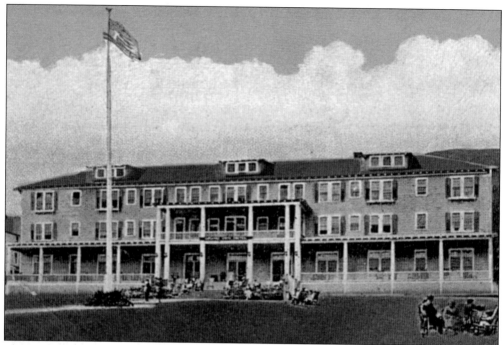

The original Grand View Hotel was built in the 1880s on Kaaterskill Junction Road, now Ski Bowl Road. It burned down in 1929 and was rebuilt as pictured here. The largest Jewish hotel in Hunter village was owned Samuel Epstein, Isaac Goldberg, Isaac Gordon, then Henry Liebowitz. The hotel was taken over by Jerry O'Shea in the early 1960s and renamed the Colonel's Table Inn. The badly deteriorated structure was taken down in 2013. (Courtesy of GS.)

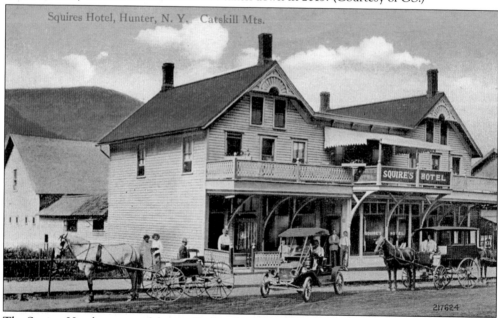

The Squires Hotel was one of the smaller hotels in the village of Hunter. Located on Main Street, in the block that burned down in a 1932 fire, it housed the post office for the village, a barbershop, and rooms for about 25 people. (Courtesy of GS.)

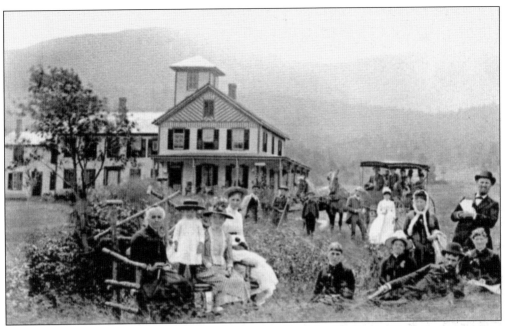

The Mountainside Cottage was built on the south side of the Schoharie Creek in the 1880s as a religious retreat and boardinghouse for the Camp Meeting Association. The location is close to the current base lodge for Hunter Mountain Ski Bowl. The walking bridge for access to the cottage crossed the creek from the main road, now State Route 23A, near the current entrance to Hunter Mountain. The sign on the bridge indicates that the proprietor was Arthur Van Gaasbeck, terms were moderate, and parties were conveyed to all points of interest at reasonable rates. Both photographs from 1886 show groups enjoying the country setting. The Mountainside Cottage burned down in 1895. It was replaced by the Alpine House (Starr Hotel), which was used as the first base lodge when Hunter Mountain Ski bowl opened in 1960. (Both, courtesy of GS.)

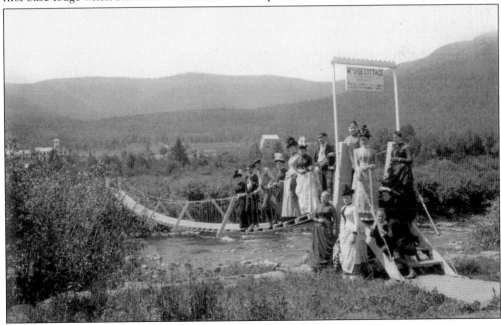

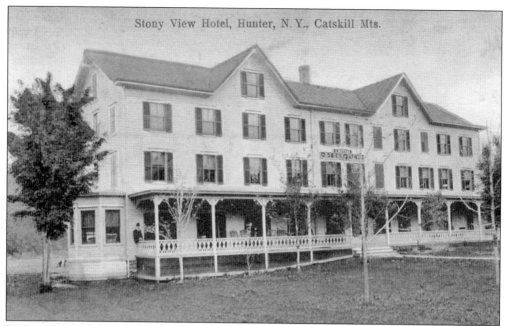

Stony View Hotel, Hunter, N.Y., Catskill Mts.

Built in the 1880s on the north side of Main Street, the Stony View Hotel was an early hotel in the village of Hunter. It was one of the few that survived into the 21st century. Before it was lost to fire in 2007, it was a nightclub popular with skiers, the Hunter Village Inn or HVI.

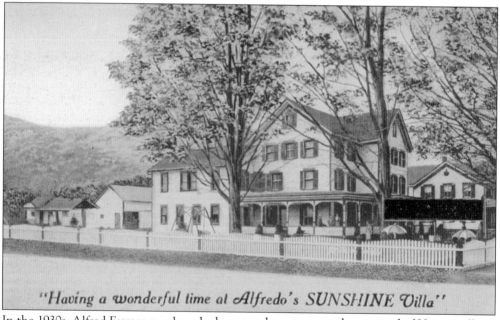

"Having a wonderful time at Alfredo's SUNSHINE Villa"

In the 1930s, Alfred Ferraro purchased a house and property on the east end of Hunter village, at the intersection of Route 32A and a side street that is now named Ferraro Road. He made needed improvements to modernize the building and opened Alfredo's Sunshine Villa, an Italian American resort. The Sunshine Villa burned in the 1990s.

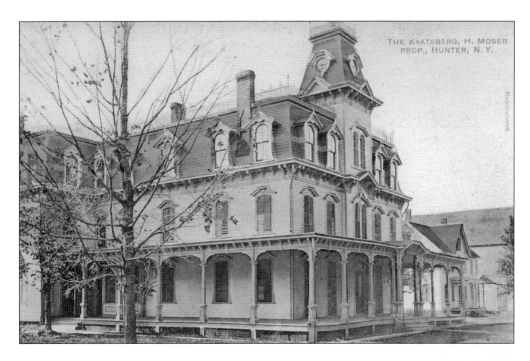

Built in 1882, the Kaatsburg was located on the south side of Main Street in Hunter village along the Schoharie Creek and among some of the highest peaks in the central Catskills. It was near the foot of Colonel's Chair and Hunter Mountain. The owner, Robert Elliott, advertised modern facilities and pure springwater for a healthful vacation. In addition, by 1910, the Kaatsburg featured a casino with bowling alleys and other indoor diversions, such as movies, to fill rainy days. The casino building later housed Gordon's Dairy.

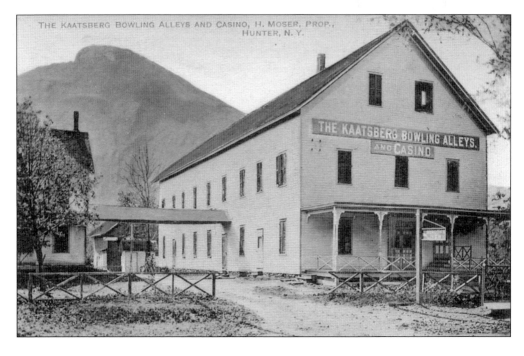

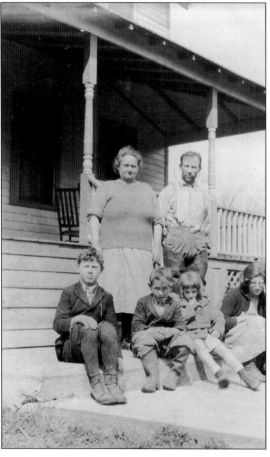

At the far western edge of the town of Hunter on State Route 23A stood Sunny Brook Farm. It was a large farm and boardinghouse that was owned and operated by Isaac Slutzky and his wife, Ella. The photograph on the left shows Ella and Isaac with their four children—from left to right, Israel "Izzy," Orville, Sadye, and Dorothy—on the front steps of the farmhouse in 1927. The family-owned business was operating into the 1950s. Izzy and Orville were the developers of Hunter Mountain Ski Bowl, which is still in the family, now owned and operated by their children and grandchildren.

Five

COMMUNITY LIFE

Hunter is a small town. The life of the community in a small town has a distinctive flavor. There is a clear sense of the interdependence of everyone in the town. Volunteer firefighters and rescue squads have been a mainstay in Hunter from the beginning and one hub of community interaction. There are volunteer fire companies headquartered in Haines Falls, Tannersville, Hunter, and Lanesville. At any time, day or night, these trained firefighters and EMTs respond to any emergency. They meet and train together regularly. They also participate in the wider community in the annual countywide convention and parade.

Another center of community life in the town of Hunter is the school. The public school system in New York State was established in 1812. Before that year, Hunter already had three schools. By 1824, there were nine school districts in the town of Hunter. In 1844, there were 736 children attending class in 20 districts—15 schools within the town and five more partly within the town. Edgewood, Elka Park, Haines Falls, Hunter, Lanesville, Platte Clove, and Tannersville each had at least one school; several had multiple schools. Before improved roads and transportation options, schools had to be situated near enough for the students to attend reasonably. In 1933, the Hunter-Tannersville Central School District was approved by the voters. The district included some students from the neighboring towns of Lexington and Jewett. Three new buildings were constructed: an elementary school in Lexington in 1935, an elementary and junior high in Hunter, and an elementary and senior high in Tannersville, both in 1937. Currently, the school is housed in the buildings in Hunter and Tannersville. The HTC school district annually graduates students ready to contribute in their community and in the world.

Churches and synagogues provide another center for community life. The earliest church in the town was the Hunter Presbyterian Church, built in 1824. There were three Catholic churches, four Methodist churches, two Presbyterian congregations, and several churches in the private parks. The Tannersville Congregation Anshi Hashoran was built in 1899, and Congregation Anshe Kol Yisroal Hunter opened in 1914.

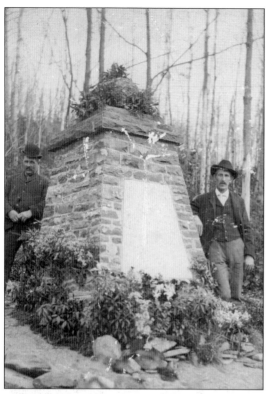

In 1901, Twilight park residents had this monument erected in memory of Frank D. Layman. Frank was an employee of Twilight Park and a volunteer firefighter. He lost his life trapped on the hillside fighting a fire with 200 volunteers in Kaaterskill Clove in August 1900. The summer had been very dry, and the fire threatened to destroy the forest as well as the grand hotels to the north.

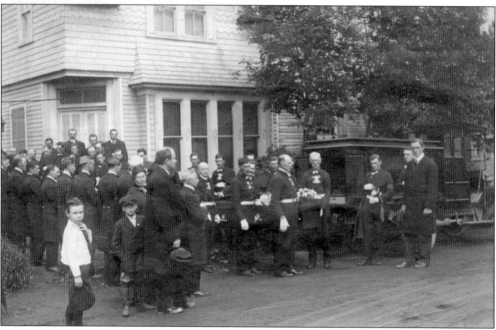

In 1915, volunteer firefighters, members of the Jacob Fromer Hook and Ladder Company in full-dress uniforms, are seen here escorting a deceased comrade from the funeral home. This scene is still common, as it is the custom for fire-company members to honor fellow firefighters who pass on by assisting at the funeral service.

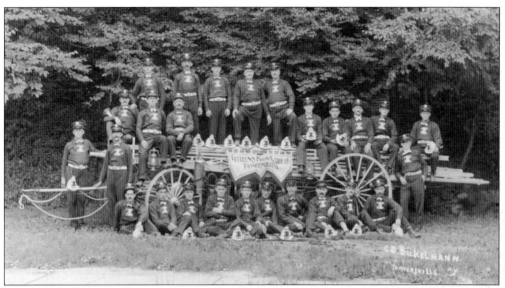

In 1910, these members of the Citizen's Hook and Ladder, Tannersville, are ready for a parade. Men included in the photograph are Herman Bickelmann (seated in front row, first on left), Morton Francis, Egbert Dibble (seated to far right), Ben Bunt, Fred Penrose, Harry Thorpe, Clarence Fowler, Art Wheat, Herb Terns, Will Peterson, and Charles Penrose. There are 26 men pictured but only 11 names recorded.

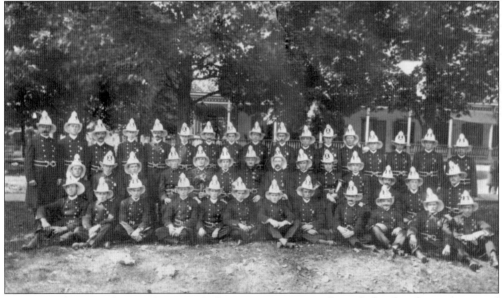

Hose Company members at the Campbell House in Tannersville include Theodore Jones, Cecil Woodard, Clarence MacDaniel, Fred Penrose, Otis Griffin, Carl Campbell, George Cole, Walter Thorpe, Bert Eggleston, Henry Delamarter, John Cole, Fred Bunt, Floyd Carn, Harry Payne, Ernest Cook, Charles Stewart, Lowell Munger, Fred Wilson, Gordon Campbell, Edward Goslee, and Fred Campbell; Jacob Fromer, Richard Haines, Samuel Hommel, Herbert North, William Bynder, Herman Bickelmann, Irving Goslee, ? Mandlestam, Bert Haines, George Woodworth, and William Lasher; Archie Schoonmaker, Russell Howard, Fred Crum, Edward Pultz, David Showers Sr., Isaac Olin, William Plass, and John Helvey.

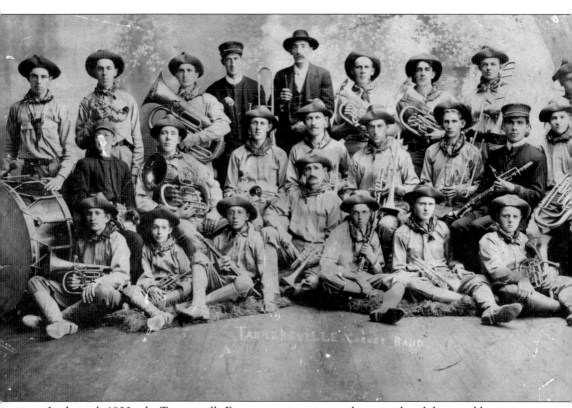

In the early 1900s, the Tannersville Fire companies sponsored a cornet band that would accompany them in parades. The only two men who are identified in this photograph are Ralph Lord (second from left, back row) and David Showers (center, front row with mustache). In addition to their firefighting duties, small-town fire companies have traditionally filled ceremonial roles marching in parades in dress uniforms. Some companies still sponsor a band.

The rustic wooden construction that was typical of the houses and inns built in Twilight Park in the late 1800s and early 1900s made them difficult to save when they caught fire. This group of firefighters is at the site of the 1907 fire that destroyed the original Squirrel Inn. It is likely that they are waiting to make certain that there will be no restart.

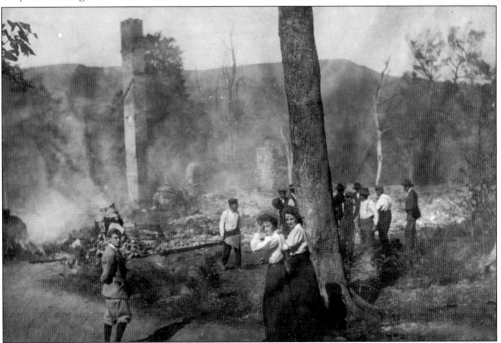

The firefighters responding to the Twilight Inn fire in 1926 were hindered by a road closure for bridge work at the main entrance to Twilight Park. The Twilight Inn fire resulted in numerous injuries and 22 deaths. The fire was reported in newspapers as far away as San Bernardino, California.

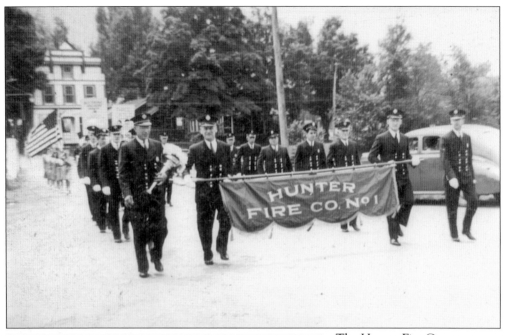

The Hunter Fire Company at the start of the Firemen's Convention parade in Hunter, September 1955, includes, from front to back, (left) Les Disten, unidentified, Leon Goodrich, and unidentified; (right) unidentified, Artie Hylan, Don Pond, Bob Goodrich, Chet Neice, and unidentified. Holding the banner are George Stronk (left) and unidentified. (Courtesy of GS.)

This is an example of a community project that is akin to a barn raising: the volunteer firefighters in Haines Falls worked with friends and family to build a firehouse on State Route 23A in 1956. The property for the new firehouse was donated by Cyril Schoonmaker.

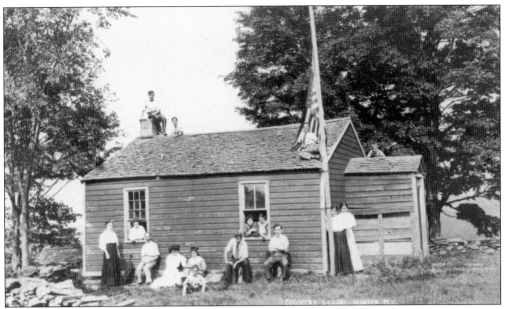

Part of the Hunter School District prior to the 1900s, one-room schoolhouses like this were scattered throughout the town. It was not expected that students would need to travel more than five miles to school. School No. 9 was located on State Route 296, between Martin's and the Griffen farm.

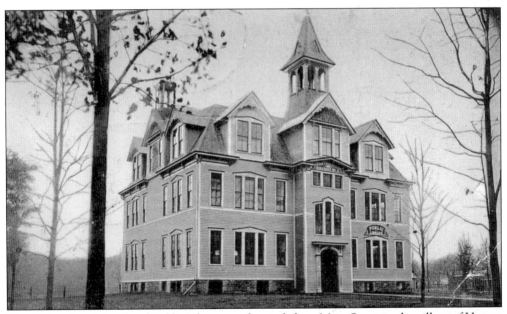

The Union Free School and Public Library was located along Main Street in the village of Hunter in 1909. It was erected in 1895 and used as a school and library until new buildings were constructed in the 1930s, when the Hunter-Tannersville Central District was established. (Courtesy of GS.)

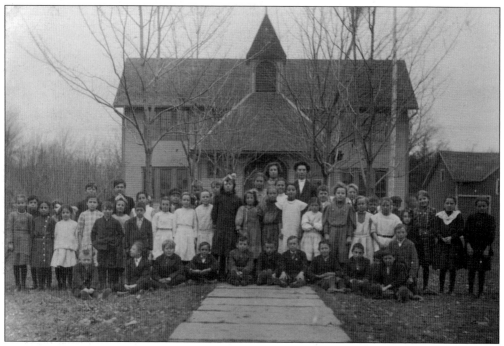

These Tannersville students are gathered for a group portrait with their teachers in front of the school in 1909. All of these students are unidentified at present.

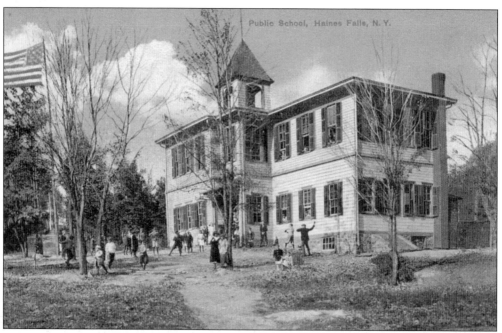

It was recess time when this photograph was taken about 1909 at the Haines Falls School located on O'Hara Road.

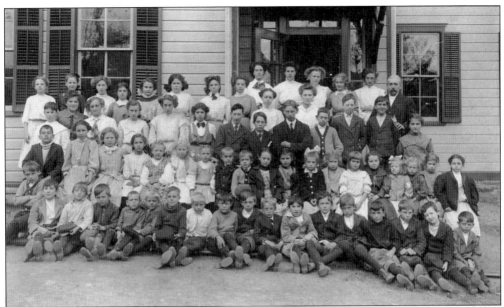

Above, the Haines Falls school picture in 1909 includes, from left to right, (first row) two unidentified, Russell Thorne, Nathan Brower, Randy Prosser, Theron Hommel, Howard Matthews, Fred Matthews, Millard Becker, six unidentified, John Lewis, unidentified, and Raymond Schoonmaker; (second row) Harold Kerr, Mabel Thorne, Liz Renner, Helen Johnson, Lillian France, Jenny Hommel, Bea Frayer, ? Valk, Floyd Lehman, Helen Haines, Sarah Ryan, Marguerite Legg, Dorothy Burton, Mae Knapp, Margaret Brower, Alma Myers, Nettie Schoonmaker, Hetty Christian, and Lillian Brower; (third row) Jack Haines, ? Valk, two unidentified, Nellie Matthews, unidentified, William Scribner, unidentified, Albert Hommel, Fred Fatum, ? Layman, unidentified, and Carrinda Valk; (fourth row) Katherine Hommel, Ethel Schoonmaker, two unidentified, Lola Knapp, Blanche Ryder, Leona Prosser, Viola Burkle, Miss Cutabach (teacher), Jenny Erbie, Miss Sullivan (teacher), Grace Eckert, unidentified, Hilda Legg, Nellie Hommel, and Mr. Payne (principal.) The same group of students and teachers is pictured below on an outing.

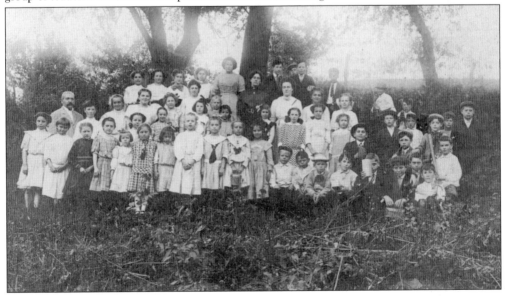

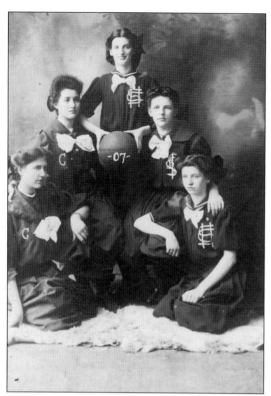

This is a surprising image of a girls' basketball team in the Hunter School in 1907. The only girl who is identified is Lucy Martin, second from right. School sports have always been an important part of community life in the small town.

This Tannersville boys' basketball team coached by James Flahive was county champion in 1932–1933. This team photograph includes, from left to right, (first row) Bob Glennon, George ?, and Ardith Traphagen Ridenensky; (second row) Samuel ?, Arnold Mandeby, Abner Harkow, Oscar Gordon, Eddie Caswell, Ira Gordon, and James Flahive (teacher and coach).

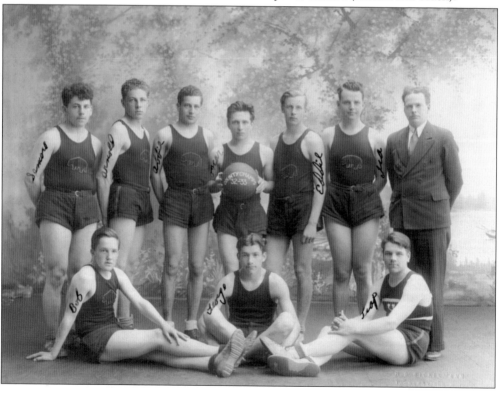

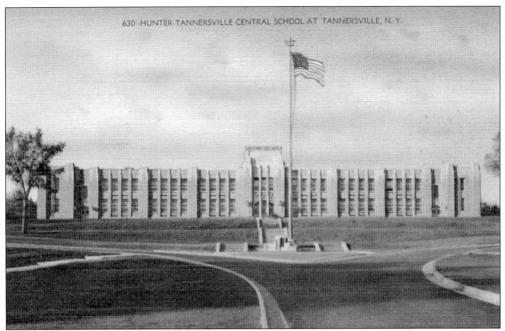

The Hunter Tannersville Central School District (established in 1933) built this high school on Main Street in Tannersville and opened it in 1937. With renovations and additions, the same building houses middle and high school students today. The custodians and staff keep it looking as good as it looked 80 years ago. (Courtesy of GS.)

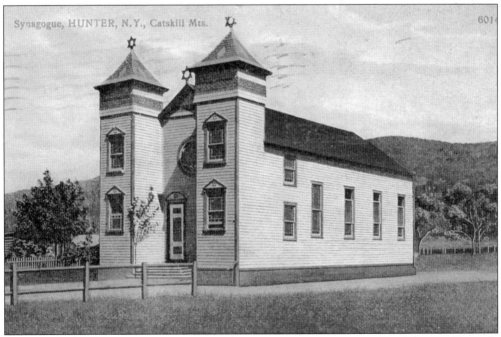

Synagogue, HUNTER, N.Y., Catskill Mts. 601

This was the original synagogue for Congregation Anshe Kol Yisroal. The synagogue currently in use by the congregation is located at 7879 Main Street, on the south side of the street. The congregation celebrated the centennial of the newer temple in 2014. (Courtesy of GS.)

The Tannersville Synagogue Congregation Anshi Hashoran is shown here in a quiet winter pose. The temple, originally built in about 1899, was moved from its original site at 6343 Main Street to this spot at 38 Tompkins Street. The cupolas that graced the roof of the synagogue were removed during this transition. The move was handled by James Wiltse in about 1918.

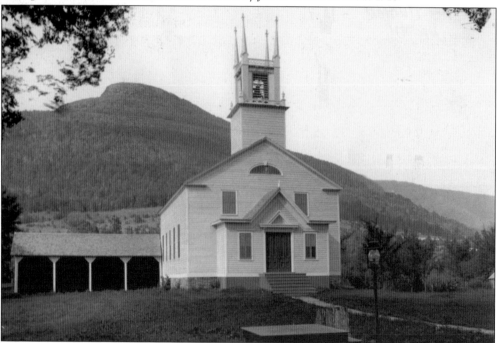

The original Presbyterian church in Hunter started in 1822, holding meetings in the loft of the Edwards Tannery, the largest tannery in the town of Hunter. In 1828, the congregation built and dedicated the first church in Hunter. Repairs were made in 1864 and a new bell added in 1867. Members of the congregation deeded their property to the Methodist conference in 1953. There is no longer a Presbyterian church in Hunter. (Courtesy of John Ham.)

The Hunter Methodist Episcopal Church was built in 1861. It was quickly rebuilt after being destroyed by fire in 1883 at a cost of $5,000—or $135,000 at today's currency rates. The church burned again in 1936 and was not rebuilt.

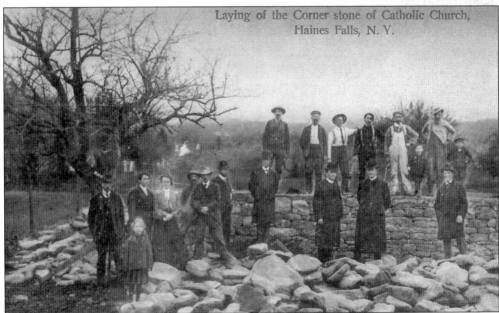

In 1907, Roman Catholic citizens of Haines Falls gathered at 55 North Lake Road to lay the cornerstone for their church, the Church of the Immaculate Conception. Of the three Catholic churches once in Hunter, this one still is open and conducting services year-round. St. Mary of the Mountain Catholic Church, established around 1840 in Hunter, is owned by the village. Money is being raised to restore it as a historic site. (Courtesy of GS.)

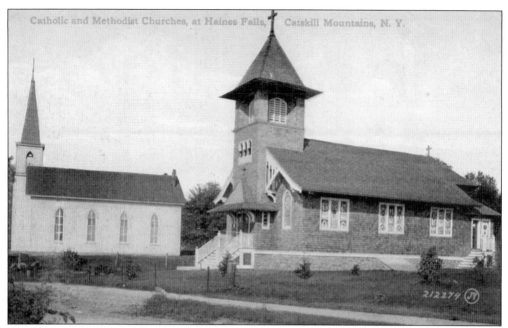

The Catholic and Methodist churches continue to stand side by side on North Lake Road as they did in the early part of the 20th century. In 1879, when it was first built, the Methodist church also served the local Presbyterian congregation.

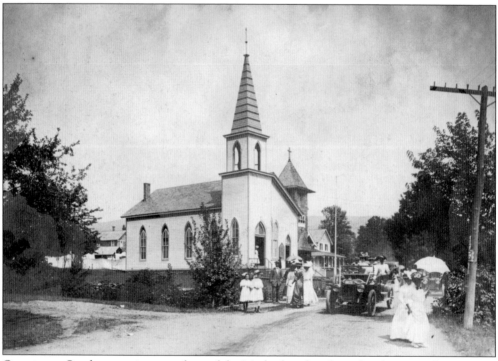

On a sunny Sunday morning, members of the Methodist church are heading out after services. It is about 1920. The women with the parasols (probably visitors to the area) are keeping their faces shaded from the sun.

The church fair was a popular community event. In August 1911, on the lawn at the Methodist parsonage, local families are enjoying a day off. Seven people in this photograph are identified by numbers written on the photograph: Nathan Brower (1), Glen Matthews (2), Nellie Matthews (3), Lena Prosser (4), Delia Harris (5), Jennie Poleschner (6), and Alice Ford (7).

The Tannersville Methodist Church was built around 1910 at 5942 Main Street. This large Sunday school class was photographed in the 1950s. Today, the Hunter, Haines Falls, Tannersville, and East Jewett Methodists have combined congregations as the Kaaterskill United Methodist Church. Their pastor, Rev. Karen Monk, holds services year-round in Tannersville and East Jewett and at Haines Falls in the summer. The Hunter building houses the thrift shop.

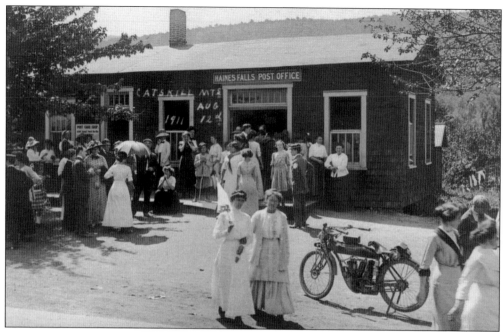

The local post office was, and is, a central part of the community, a place to catch up with neighbors and exchange a little gossip As this photograph shows, the postmaster's job more than doubled in the summer months when visitors came to the Mountain Top. In 1909, the postmaster closed the post office while he was sorting mail, otherwise there was too much noise and commotion.

In this photograph, Justine Hommel is leaving the Haines Falls post office in the winter of 1958. In that year, there were 164 inches of snow in the town of Hunter. Justine is a central figure in the Hunter community. She was married to Hillard Hommel and served as the town librarian, town historian for Hunter, and a founding member and longtime president of the Mountain Top Historical Society.

Six

GOOD TIMES

In the 1800s and 1900s, as the area around Hunter was settled by hardworking pioneers, people came from all over the world to see the awesome vistas, breathe the fresh air, and have a good time. Hiking the trails around the grand hotels was one of the things that visitors to the area enjoyed doing. Livery drivers offered scenic carriage rides around the area. Music and dances were featured in many of the large hotels. Hotels, inns, and boardinghouses had wide lawns for croquet and tennis and quiet parlors and sunny verandas for playing cards, reading, or chatting with friends. Artists came to paint the wild beauty of the Catskills.

There were theaters throughout the town showing movies and presenting live performances. In the early 20th century, golfers could find at least six golf courses in the town of Hunter. In the 1930s, there was an airport in Elka Park that offered sightseeing rides and aerial shows at its airstrip south of Tannersville. Tourists could go boating on North and South Lakes, on Rip Van Winkle Lake in Tannersville, and on Dolan's Lake in the village of Hunter. The lakes and streams offered opportunities for fishing. New York State campgrounds were available for the adventurous beginning in 1926. In the 1950s, a children's amusement park called Rip's Retreat opened near North Lake. Summer camps for children became part of the tourist economy, mainly in the village of Hunter.

In the 1960s, when the Hunter Mountain Ski Bowl opened, there were new activities for the tourists to the area and not only in the winter. In the 1970s, a series of festivals (German Alps Festival, Celtic Festival, Polka Festival, and so forth) became a feature of the summer season at Hunter Mountain.

Today, those original hiking trails, first cut by the owners of the hotels, are part of a vast network of trails maintained by the New York State Department of Environmental Conservation and open to the public. The present Hudson River School Art Trail takes artists and art lovers to the places where the famous painters drew inspiration.

Hiking on the trails around the Catskill Mountain House and Kaaterskill Hotel, these two unidentified men (left) and two unidentified women (below) have found just-right places to sit and enjoy the view of the Kaaterskill Clove. The men are seated on Sphinx Rock looking over the clove from its north wall. The women have a different vantage point. There are many of these vistas, and they are still accessible to modern hikers in the Catskill Park.

Kaaterskill High Peak rises next to Round Top as one looks south beyond Twilight Park from Haines Falls. There is a state trail to the top of the mountain accessible through Twilight Park (with permission) or from Platte Clove. The summit of High Peak is 3,800 feet high. A builder improved the view by erecting an observatory that resembles the original wooden fire tower placed on Hunter Mountain in 1909. This tower was referred to as High Peak Observatory. The sign on the tower names the collection of buildings around it "Lincoln's Inn." In the time period after President Lincoln's assassination, there were many places named for him. There was even a suggestion to change the name of Kaaterskill High Peak to Mount Lincoln. The Lincoln's Inn sign may place this photograph in the late 1860s to the 1880s.

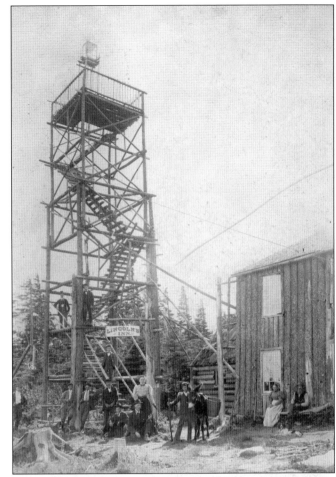

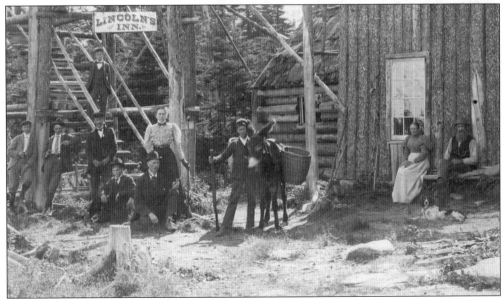

Alligator Rock has been alongside the trail around North and South Lakes since the glaciers melted away. It is an erratic that was transported to that spot and left behind by a glacier. As soon as people started hiking past it, they started decorating its mouth with stones for teeth. There are those who think it look more like a whale or a shark than an alligator.

These unidentified hikers from one of the grand hotels are using the type of walking stick that was commonly available at those hotels. The Mountain Top Historical Society has a similar staff from the Hotel Kaaterskill in its archives.

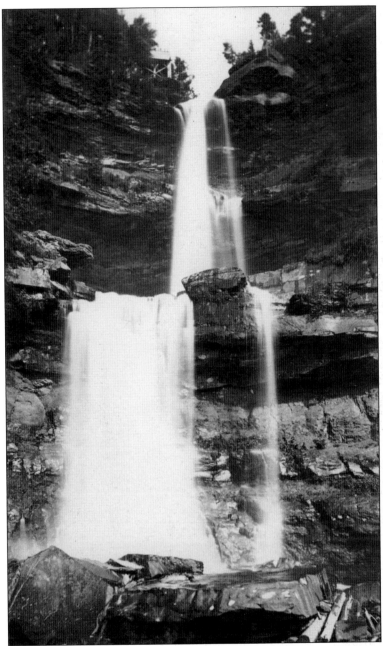

The most prized view on the trails around the Catskill Mountain House is the one of Kaaterskill Falls from its base. The falls shoot over the top rim near the site of the Laurel House, tumbling about 167 feet to a pool and then falling another 65 feet to the rocky base. The actual height of the falls has been a matter for discussion ever since they were seen by romantic artists, writers, and tourists. Earlier estimates and publications put the height of the falls at 260 feet, the tallest in New York State. The actual height has more recently been measured at something closer to 230 feet. It matters little when one stands in awe looking up at the sight. The paintings of Thomas Cole and the writing of James Fenimore Cooper bear witness to the beauty of the scene. It is a view that rewards the hiker who makes the half-mile climb up the hill from Bastion Falls.

Another place of beauty and renown among hikers is Fawn's Leap, a 24-foot-high waterfall deep in the Kaaterskill Clove along State Route 23A near Palenville. The most common legend regarding the name of the falls is the one about a doe followed by her fawn. The doe leaps easily across the rocks above the Kaaterskill Creek, but the fawn falls into the churning water. In some versions of the story, the fawn survives the fall; in other versions, he does not make it. Still other storytellers add a dog chasing the two deer. In the early part of the 19th century, this area was the site of the settlement known as East Hunter. There are remnants along the creek of the tannery that operated between 1817 and 1866. Also located near Fawn's Leap was Brockett's Inn, a place where Hudson River School artists found lodging while working in the region.

This view looking west at Haines Falls on the Kaaterskill Creek shows the proximity of the falls to the Haines Falls House, located along the main road in the hamlet of Haines Falls. The Haines Falls House burned down in 1911. This site could be reached by hiking west through the clove from Fawn's Leap past the junction where Lake Creek enters Kaaterskill Creek below Kaaterskill Falls.

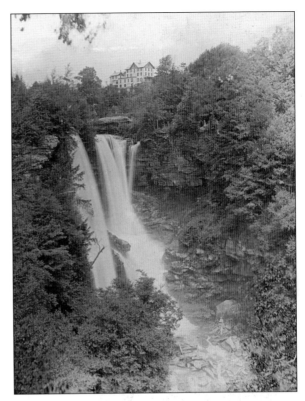

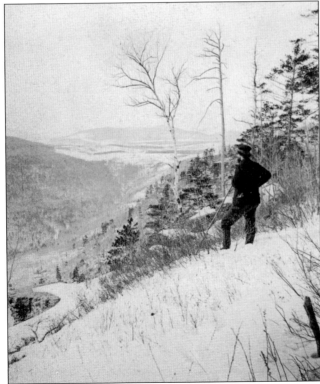

The tourist in this 1860s stereograph is standing near Sunset Rock, currently called Inspiration Point, looking west toward the hamlet of Haines Falls.

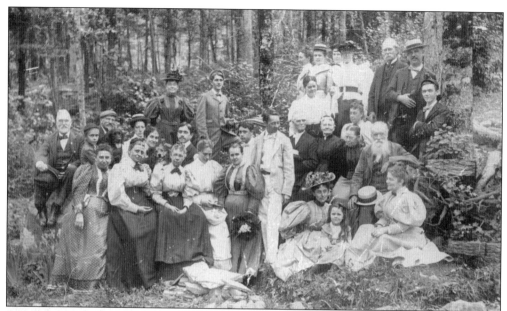

John Burroughs, the noted naturalist, lived in the western Catskills and made trips to the area around Hunter to visit friends and hike in the woods. Here he is, the man on the lower right with the white beard, the center of attention among a group of Twilight Park cottagers.

Families spending time at their cottages in Twilight Park found ways to keep the children entertained with plays, costume parties, and walks in the woods. It was a simpler time, long before children needed television to entertain them.

The Myers family owned property in Haines Falls and were full-time residents in a place that hosted many tourists. In this photograph from the early 1900s, Marwood Myers and a friend are enjoying the diversion of a ride in a goat cart.

This unidentified man is embarking on a ride down the Rip Van Winkle Trail in the early 1900s. The automobile was another way to tour the Catskill High Peaks, and it marked the beginning of a very different era in American recreation and vacation habits. It was in 1924 that New York State passed a law requiring a driver's license. Prior to that date, only chauffeurs required a license.

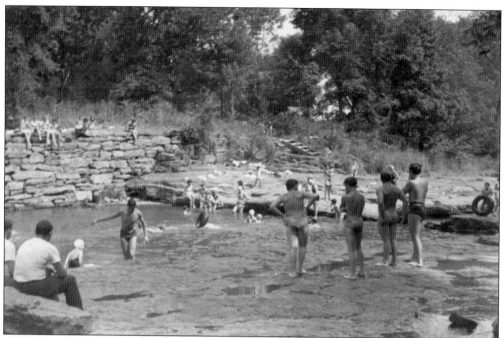

This swimming hole in Hunter village was on the Schoharie Creek behind the row of businesses along Main Street. In the summer, locals and visitors could all be seen walking on Main Street with towels over their shoulders, ducking down the various paths leading to this refreshing spot. These swimmers are there sometime in the 1950s.

The old swimming hole in Hunter was a scenic and much quieter place in the winter. (Courtesy of GS.)

Lake Rip Van Winkle, Tannersville, Catskill Mts., N. Y.

In Tannersville, Rip Van Winkle Lake (also known as Meadow Brook Lake and Voss's Lake) was the place for swimming, boating, and fishing in the warm summer months. The lake could be reached from Spruce Street or by walking south on Lake Street from the village. This photograph shows the boathouse and boaters enjoying the clear air in 1915. (Courtesy of GS.)

Rip Van Winkle Lake was used in all seasons. In this 1920 photograph, boating has ceded to ice hockey on the frozen lake, drawing a good crowd of onlookers. The building on the right on the hill is the O.H. Perry Lumber Company. The Ulster & Delaware train station can be seen in the center. The annual ice-fishing derby is still held at Rip Van Winkle Lake. (Courtesy of GS.)

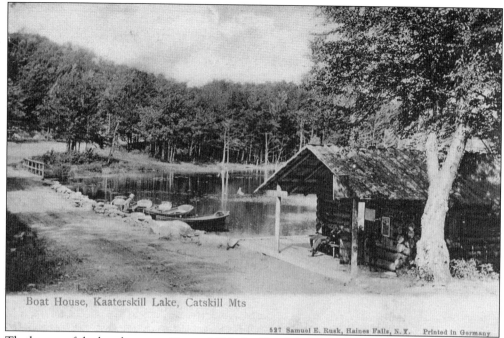

Boat House, Kaaterskill Lake, Catskill Mts

527 Samuel E. Rusk, Haines Falls, N.Y. Printed in Germany

The keeper of the boathouse on Kaaterskill Lake (South Lake) is sitting in the shade of his cabin waiting for guests from the nearby hotels to rent the boats in the early 1900s. The New York State Department of Environmental Conservation maintains a boat concession at North Lake, renting out canoes and kayaks for exploring North and South Lakes. (Courtesy of GS.)

RECREATION HOUR, DOLAN'S LAKE, HUNTER, N. Y. IN THE CATSKILL MTS.

This 1937 photograph by H.G. Bickelmann of Tannersville depicts a group of boaters and swimmers at Dolan's Lake in the village of Hunter. (Courtesy of GS.)

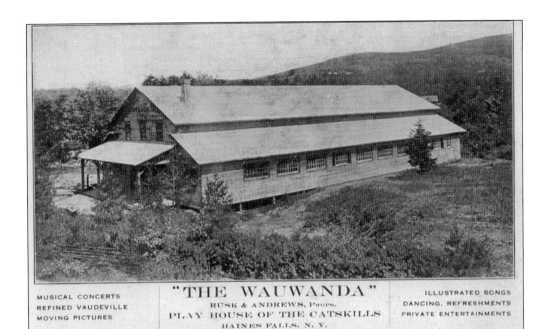

MUSICAL CONCERTS	"THE WAUWANDA"	ILLUSTRATED SONGS
REFINED VAUDEVILLE	RUSK & ANDREWS, Props.	DANCING, REFRESHMENTS
MOVING PICTURES	PLAY HOUSE OF THE CATSKILLS	PRIVATE ENTERTAINMENTS
	HAINES FALLS, N. Y.	

The opening date for the Wauwanda Theater is a little unclear; however, the poster below advertises a show on Saturday, July 20, which would make it 1912. The Wauwanda was built in Haines Falls by Rusk and Andrews. They dubbed it the "Playhouse of the Catskills" and offered a wide range of entertainment. Moving pictures, refined vaudeville, dancing, musical concerts, and illustrated songs, along with refreshments, were all on the schedule. The theater was open six nights a week in July and August. At some later date, the Wauwanda became the Rip Van Winkle Theater and featured the Rip Van Winkle Players, a professional stock company, for a two-month season each summer. In the 1920s, St. Mary's Theater behind Immaculate Conception Church on North Lake Road showed an up-to-date talking picture every night at 8:30 p.m.

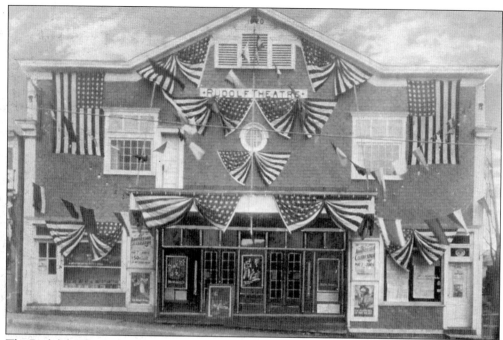

The Rudolph Theatre was an open-air theater on Main Street in Tannersville in the early 1920s. It was replaced by the Orpheum, which opened on that site in 1927. In 1905, there was another open-air theater in the village of Hunter near 7457 Main Street. The theater, Thomashefsky's Paradise Gardens, was owned by Boris and Bessie Thomashefsky, the stars of Yiddish theater in New York City.

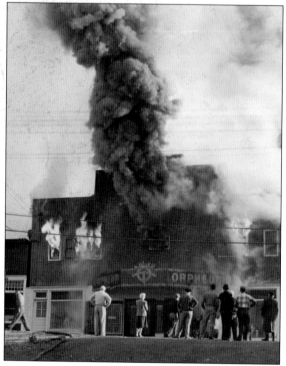

When the Orpheum Theater opened, the St. Mary's Theater in Haines Falls closed. As seen in this photograph by Daniel O. Showers, the Orpheum burned in 1953; it was later rebuilt. The Orpheum has recently been rebuilt again in a partnership between the Catskill Mountain Foundation and the Hunter Foundation as a performing-arts center presenting music, dance, plays, and films.

The Twilight Park golf course, called the Mountain Golf Course, opened in 1906, a nine-hole course on 20 acres. The course closed in 1941 due to the effects of the recession. The golfers pictured here in the 1920s are, from left to right, John Glennon, Bill Gressick (the course pro), William Horn, and Frank Hobby.

These golfers are, from left to right, Horace Stanton, Earl Carnright, John Glennon, and Bill Gressick. The three young local boys may be learning about the game from the pro, Bill Gressick, on the Mountain Golf Course in the 1930s. There were also golf courses at Hotel Kaaterskill, the Laurel House, Onteora Park, the Fairmont Hotel, and at the Tannersville Country Club, still open as the Colonial Country Club.

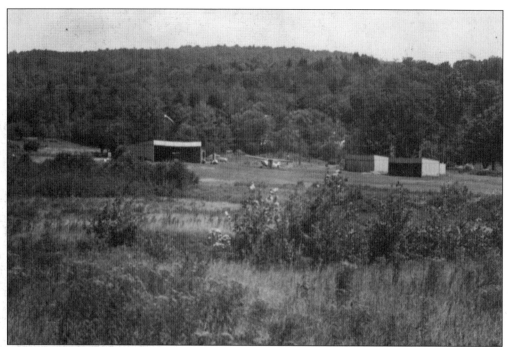

In 1929, 1930, and 1931, Tannersville boasted an airport at the intersection of County Route 16 and Elka Park Road. Excited crowds gathered to watch air shows and death-defying parachute leaps. The owner of Rip Van Winkle Airways, Perry Edwards, charged $5 (about $70 in today's currency) for an aerial tour. The 1930s was a big time for barnstormers all across the United States, and the Catskills were a great place for them to perform. In 1946, the airport was reopened by a man whose last name was Zitter, but the enterprise did not last long. Two of his planes were wrecked by the end of that summer; the fall winds destroyed the two hangers on the right in the photograph above. The hanger on the left was refitted as a bar and inn, named Shamrock Inn.

On October 5, 1934, Charles Myer celebrated his 10th birthday with his grandfather and friends in Haines Falls. Picture, from left to right, are (first row) Dorothy Valk, Audrey Bunt, Alvin Firmalino, Carl Poleschner, Joe Feml, Howard Thorp, George Hommel, Pat O'Brien, Leon Slater, Edward Firmalino, John Lampman, Dorothy Lampman, and Joan Knapp; (second row) Arlene Matthews, Ann O'Brien, Billy Rider, Burton Legg, Harry Layman, Gloria Knapp, Bonnie Carnright, Hillard Hommel, Audrey Lampman, and Joan Bunt; (third row) Ann Firmalino, Myrtle Firmalino, Justine Legg, Minnie Gardner (Schutt), Doug Layman, Ruth Woodard, Charles Myer, Dolly O'Brien, Audrey O'Brien, Marjorie Brower, Lloyd Knapp, Danny Rider, and Jimmy O'Brien; (fourth row) Henry Myer, Charles's grandfather.

In the 1951, a children's amusement park opened on property adjoining the North Lake Campground. It was called Rip's Retreat, and its theme centered around Washington Irving's story of Rip Van Winkle and his 20-year sleep in the late 1700s, set in the Catskills. The buildings in the park were modeled on Dutch-style buildings from the 18th century. The park featured artisans in their shops producing handcrafted items for sale and hands-on activities for children. There was glassblowing, candle-making, and woodworking. Large wooden shoes were used as playground props. There was a puppet theater presenting the story of Rip. Rip (Hiram "Hype" Hoyt) and his dog, Wolf, wandered around the grounds. There was a petting zoo, ninepin bowling, and a train ride through a "Fairyland in the Sky." Local people, including high school and college students, could find summer work playing the various roles needed in the park. The park closed in the 1960s, and the property was acquired by the New York State Department of Environmental Conservation for North Lake State Park.

116

On May 31, 1954, C. France, John Colton, and Mike Flahive are playing ninepins at Rip's Retreat amusement park. In the story by Washington Irving, Rip Van Winkle meets strange men from Henry Hudson's lost crew. They invite Rip to drink ale and bowl with them. It is the last thing Rip remembers before falling asleep for 20 years.

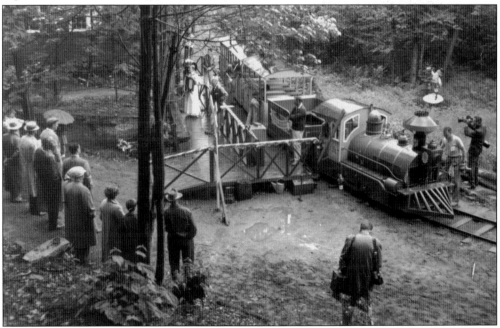

This photograph shows the opening day of the newest addition to Rip's Retreat, a train ride. Owners of the park, news reporters, and families are gathered on a gray day for the special event. The train ride winds through Fairyland in the Sky. Traces of Rip's Retreat and its train route can still be found by hikers in the area around North Lake. (Courtesy of Larry Tompkins.)

In this 1930s photograph from a Haines Falls Methodist Church picnic, the boys in the front are proving that boys will be boys. According to the back of the photograph, the two boys up front are Charles and Marwood Myers. The boy with the banana in his mouth is Howard Thorp, and Nellie Ayers is standing on the left. The other names listed are Edna Duncan, Louise Kerr, and Frances Schutt.

This parade on Main Street in Tannersville in the 1950s is a reminder that Tannersville has been, and still is, the place for parades in Hunter. There are parades every year for St. Patrick's Day, Memorial Day, the Fourth of July, Columbus Day, Halloween, and Veterans Day. It takes a good corps of volunteers to keep these traditional community events happening.

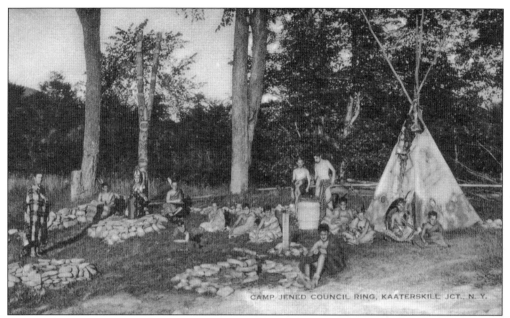

Among the summer camps that were common in Hunter beginning in the 1950s was Camp Jened. It operated at a site on Kaaterskill Junction Road (Ski Bowl Road) until 1980. Camp Jened provided an informal, fun, age-appropriate camping experience for children and adults with physical and developmental disabilities. In 1960, Camp Jened focused on serving adult males (over 18 years old) with developmental disabilities. (Courtesy of GS.)

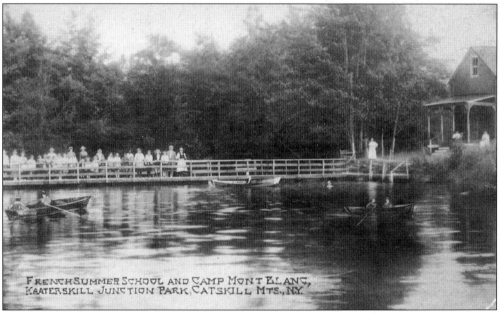

Located in the same area as Camp Jened, this French summer school, Camp Mont Blanc, also brought children into the mountains for summer camp activities along with French-language classes. Other summer camps in Hunter included Camp Meadowbrook (later Camp Abelard), Camp Mayfair, Camp Stony Clove, Camp Loyaltown, and Camp Schoharie. Camp Loyaltown is the only one still operating today. (Courtesy of GS.)

Nathan Dolinsky, pictured here around 1930, and his wife, Blossom, opened Camp Schoharie in Hunter in 1920. It was their aim to provide boys and girls nine to 17 years old educational summer fun. They offered sports, painting, singing, dance, and music. Camp Schoharie flourished for 40 years and then began a decline that led to its closure in the early 1970s. Local students attended the camp along with children from New York City and environs. The stone pillars at the entrance to the camp are still visible on the right as one drives north on State Route 296. There is also a street sign for Nathan Dolinsky Road. (Both, courtesy of GS.)

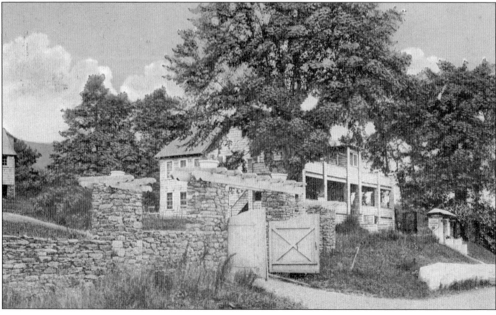

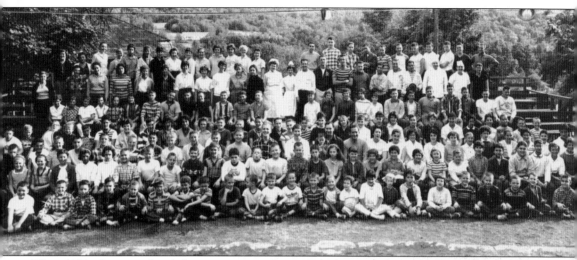

This 1959 photograph of the campers at Camp Schoharie includes local campers Gary Slutzky, Carol Slutzky Tenerowicz, Paul Slutzky, David Slutzky, David Goldstein, and Mattie Shershoff Soukis.

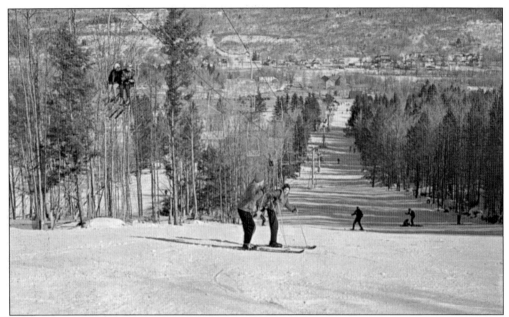

Skiers are getting ready to head down the slope named Madison Avenue in 1960 at Hunter Mountain Ski Bowl. Hunter Mountain has expanded from that early season to provide accommodations for all levels of skiers and snowboarders, a snow-tubing park, and even a zip line. (Courtesy of GS.)

During the 1970s, a full lineup of festivals opened at Hunter Mountain in the summers. For the German Alps Festival, dancers and bands were brought to Hunter from Germany to perform in the traditional style. Along with the music, there was German food and beer to enjoy and a wide variety of German imports to buy. The original German Alps Festivals were in town for three weeks. (Courtesy of GS.)

On rainy days or when a quiet time was a just-right choice, this children's reading corner at the Haines Falls Free Library was the place to be. That library, which served for many years, has recently moved to a new building in Tannersville, the Mountain Top Library, with more room for books and technology services for the community. In addition, the Hunter Public Library and librarian June Bain have served the residents of Hunter village for over 45 years. (Courtesy of GS.)

These three young women in the late 1800s are having a good time modeling the latest fashion in ladies' hats.

These hikers made the trek to the top of Kaaterskill High Peak and have stopped for a photograph before heading down. A couple of the hikers are identified. Third from the left is C.B. Legg, second from the left, Charles Poleschner, and second from the right, Frank Layman. Frank died in August 1900 fighting a devastating fire in Kaaterskill Clove. He was 24 years old at the time.

These hikers are standing at the place that was designated Sunset Rock during the 1800s. Modern hikers looking for the same views need to check a trail guide with references to the older names for significant landmarks.

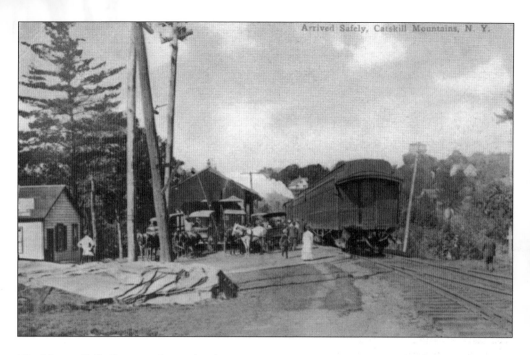

The Haines Falls Station, alongside what is now State Route 23A, served passengers heading to the Hotel Kaaterskill on the Kaaterskill Railroad until it was replaced by the Ulster & Delaware station in 1913. The newer station was situated farther east and back from the main road on property that belonged to Charles Martin, owner of the Lox-Hurst. It was built to handle the growing number of passengers flocking to the Hunter area resorts in the early 20th century. The new station had room for more people and baggage and plenty of parking for the wagons and cars picking up passengers, alleviating the congestion that was occurring along the Main Street in Haines Falls by 1911.

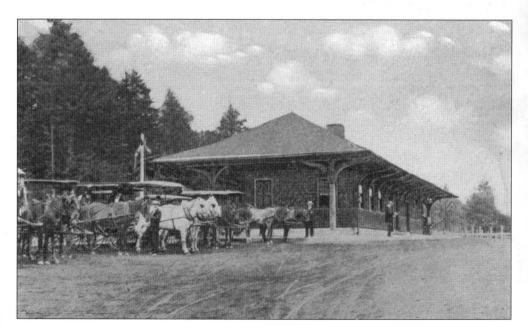

BIBLIOGRAPHY

Beecher, Raymond. *Kaaterskill Clove: Where Nature Met Art*. Hensonville, NY: Black Dome Press, 2004.

Beers, J.B. *The History of Greene County*. Cornwallville, NY: Hope Farm Press, 1969.

Evers, Alf. *The Catskills: From Wilderness to Woodstock*. Woodstock, NY: Overlook Press, 1972.

MacGahan, John. *Twilight Park, the First Hundred Years*. South Yarmouth, MA: Allen D. Bragdon, Publishers, Inc., 1988.

Titus, Robert. *The Catskills, A Geological Guide*. Fleischmanns, NY: Purple Mountain Press, 1993.

————. *The Catskills in the Ice Age*. Fleischmanns, NY: Purple Mountain Press, 2003.

Van Zandt, Roland. *The Catskill Mountain House*. Hensonville, NY: Black Dome Press, 1991.

Wiltse, Leah, edited by Shirley Wiltse Dunn. *Pioneer Days in the Catskill High Peaks*. Hensonville, NY: Black Dome Press, 1999.

About the Mountain Top Historical Society

The Mountain Top Historical Society was founded in 1974 by a group of people interested in local history and concerned about the resources that were being lost as documents and photographs were cleared out and thrown away. The original members of the board of the society applied for a state charter to function as a not-for-profit educational institution in the state of New York and went to work. Their mission was, and is, to discover, interpret, preserve, and share our history. They held lectures on local history topics that were free and open to the public. They led hikes throughout the Hunter area, following in the footsteps of the artists, writers, botanists, and tourists who made history. They started collecting the ephemera that supports the story we tell about ourselves and our home in the mountains.

In 1997, the Ulster & Delaware Railroad Station in Haines Falls, which had fallen into disrepair, was available for purchase at a good price. With the support of several major benefactors and many smaller donors, the MTHS acquired the station and began the huge job of restoration. The station is now the centerpiece of a 20-acre campus at the western end of Kaaterskill Clove on State Route 23A at the former site of the Lox-Hurst. In addition to the station, the Mountain Top Historical Society maintains a visitors' center at 5132 Route 23A with information to guide those interested in hiking our historic trails or seeing our scenic vistas. We have an introductory display about the artists of the Hudson River School who helped open the area to tourism in the early 1800s. Our visitors' center features a secure archives room with temperature and humidity controls to preserve our growing collections. We present lectures and hikes during a season that runs from May to October. The MTHS is a volunteer organization dedicated to the mission begun in 1974. More information is available on our website, www.mths.org,

All of the authors' proceeds from the sale of this book will be donated to the Mountain Top Historical Society.